EXPLORING KITTENS

STORY AND PHOTOS BY NOBUO HONDA

Heian

Heian International, Inc.
1815 W. 205th Street Ste. #301
Torrance CA 90501
Web site: www.heian.com
E-mail: heianemail@heian.com

ISBN: 0-89346-888-6

Printed in Hong Kong

Plates

Two and a half years ago, I was adopted—by a cat. Not ever having experienced this phenomenon before, I did not know what to expect or how to act. I still don't! This free soul has made my house her home, but even after this length of time, she acts as though we were strangers. She does not let me pet her, much less hold her; and if I should inadvertently walk by her too closely, I am greeted with a throaty warning. When I bring her meals, she glares at me accusingly as if I had kept her waiting and starving for hours. Truly, she is the most unfriendly and unloving cat I have ever met—yet, she has the cutest face.

A little while back she became pregnant. Like a fool, I rushed around preparing a nice, comfortable place for her to have her kittens and to nurse them. I really should have known better. The ungrateful creature had her babies someplace else. Although the mother did not appreciate my company, I hoped the kittens would. Wanting the kittens to get used to me, I waited until the mother cat left them alone, then reached out to play with them. I received the same welcome that I would expect from their mother: yelling and screaming, they clawed and scratched my hand, which I quickly pulled back. Hearing their tiny cries, mother cat came flying back—eyes flashing, teeth and claws bared. I beat a hasty retreat.

Mother cat also had problems with them. When the kittens began to explore the world outside the nest, she became very nervous. She would rush after a stray, grab it by the scruff of the neck, and return it to the nest, only to discover the others out and wandering around. Back and forth she went, picking up one after the other, until the poor thing was completely exhausted. My hesitant gestures of help were rejected in no uncertain terms.

After a month or so, the kittens began to venture out of their room. They soon discovered the stairway and invented their own method of reaching the bottom. What a hilarious sight it was to see four or five little balls of fur rolling down the stairs. Since none of them were ever hurt by this exercise in kitty-gymnastics, all my worries were needless.

Eventually they explored the whole house, agreed that it was suitable, and audaciously took complete possession of the property. They would run around with tails flying, chasing one another, and were in, under,

and around everything, only to suddenly take a catnap wherever they happened to be. Of course, mother still had the last word; one call from her and the troops were at her side in an instant. Ah, to command such love and devotion.

During the two to three months from the time of their birth until their adoption, all my days off were spent photographing them. By this time, the mother cat left her kittens pretty much alone. However, she attended all the photo sessions and kept an attentive eye on me. If I became too engrossed in my work and forgot about the time, she would let me know that the session was running too long by sneaking up behind me and, with a somewhat gentle claw, alerting me of the time and the effectiveness of her sharpening technique. Sometimes her claw would get caught in my pants, scaring us both and causing a bit of confusion.

Most of the photos in this book are the result of those sessions. However, my photographing kittens did not end there. In fact, that was just the beginning. It was not difficult to find others that intrigued me, some of which I have also included in this book. As I look at each picture, I fondly remember the unique personality of each kitten.

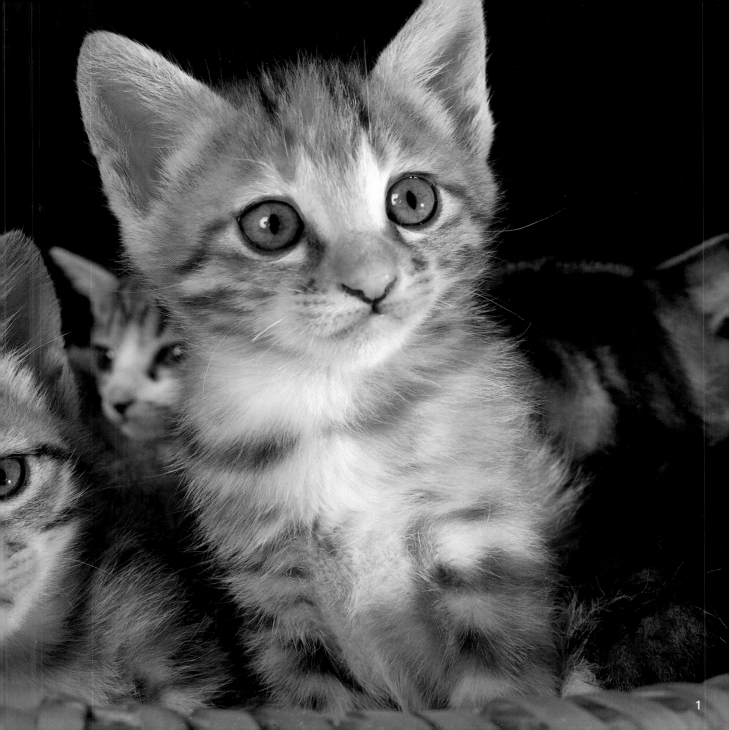

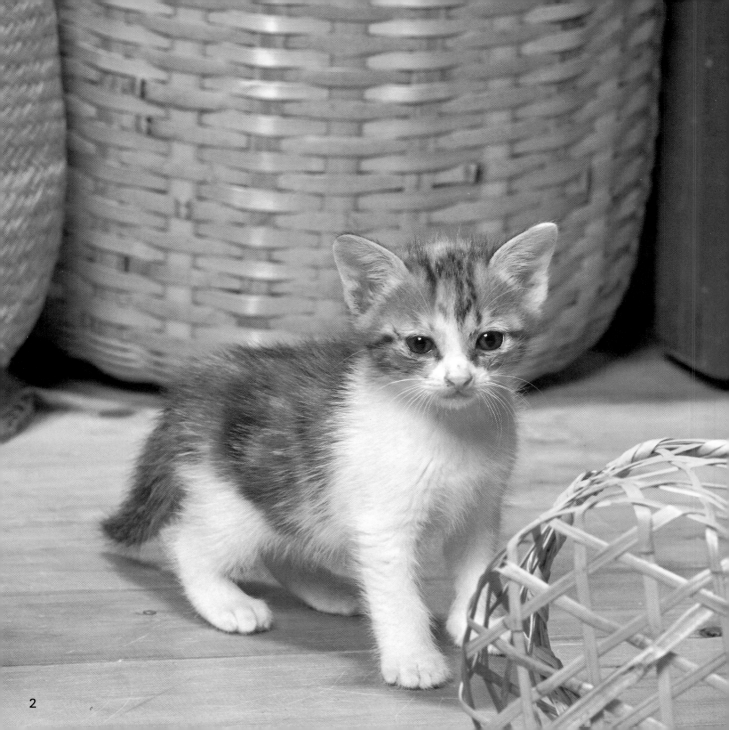

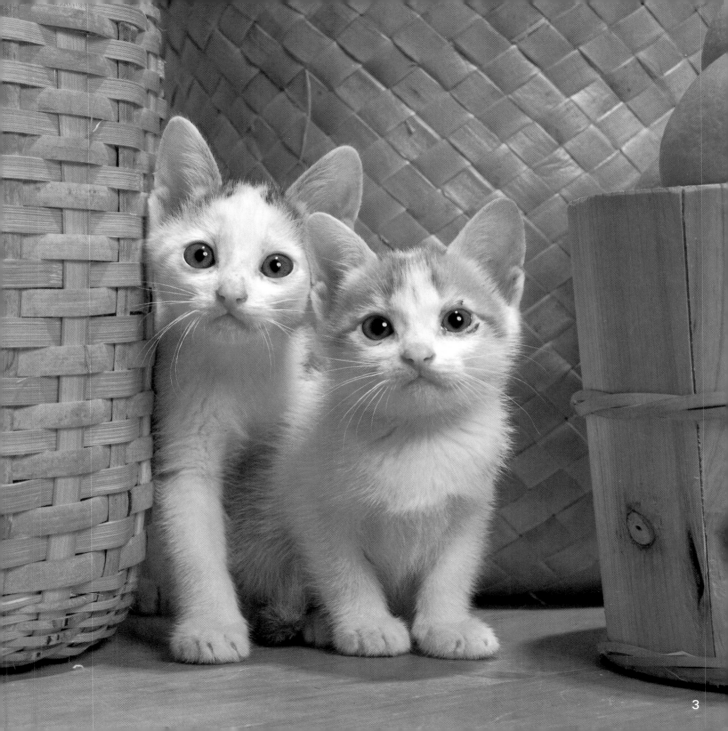

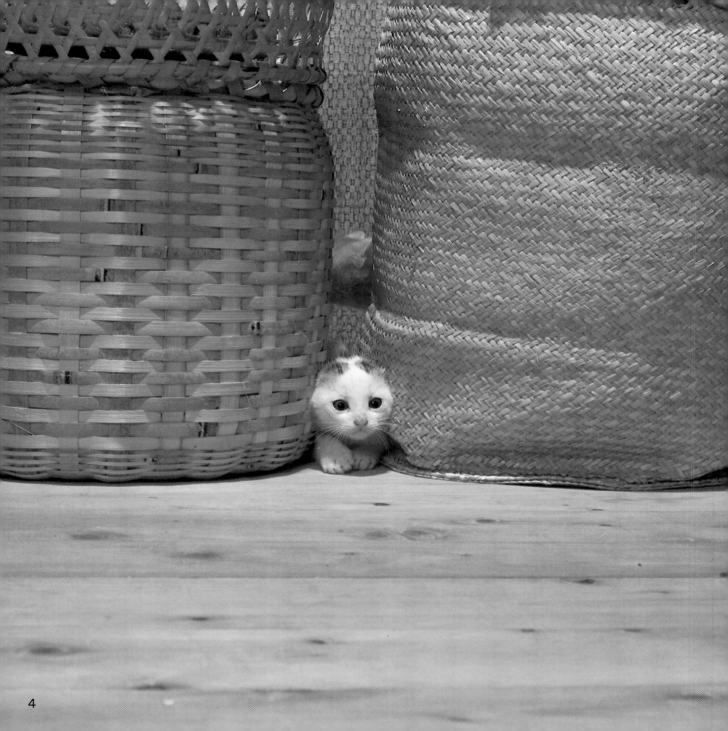

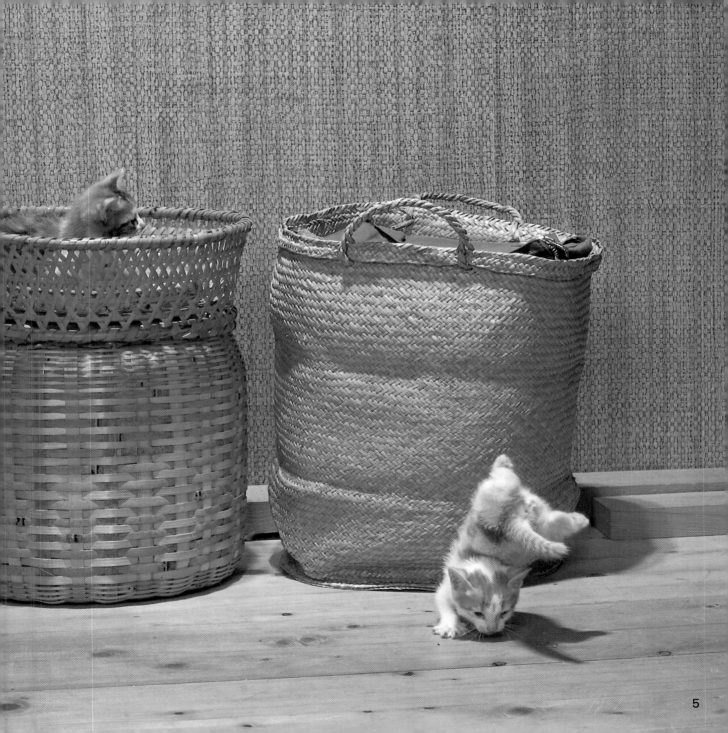

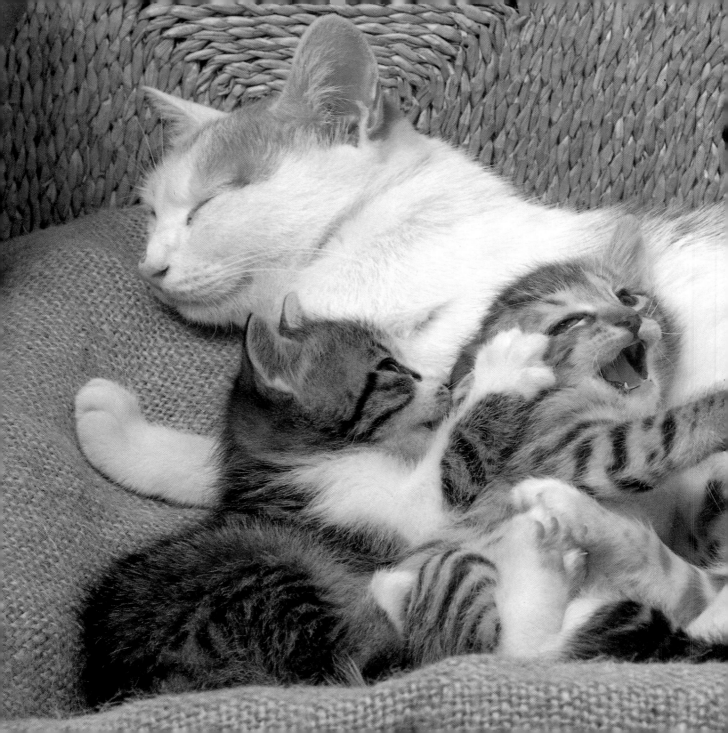

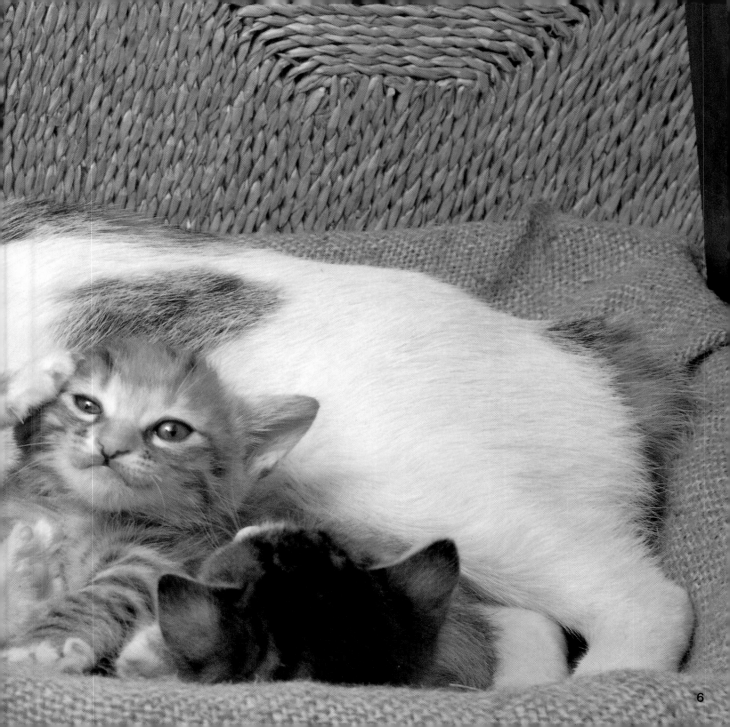

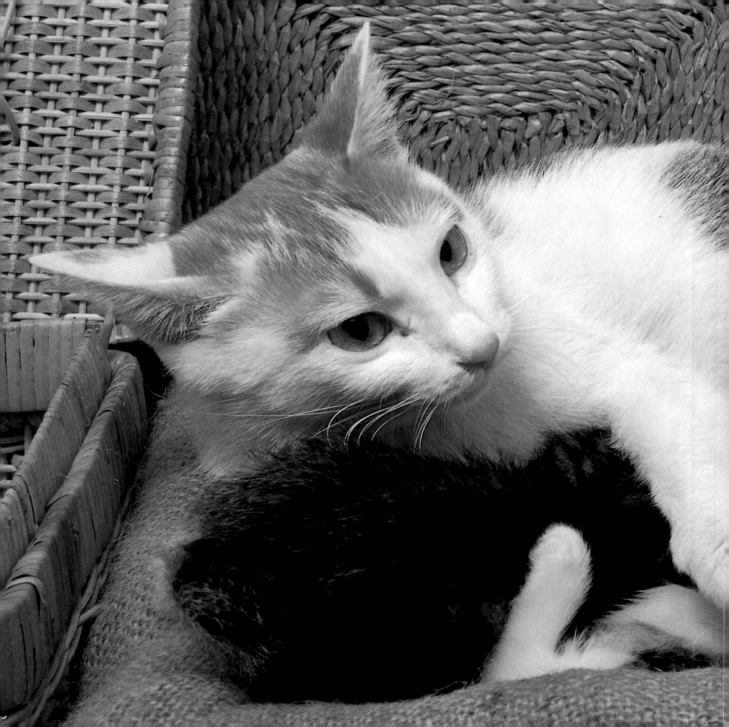

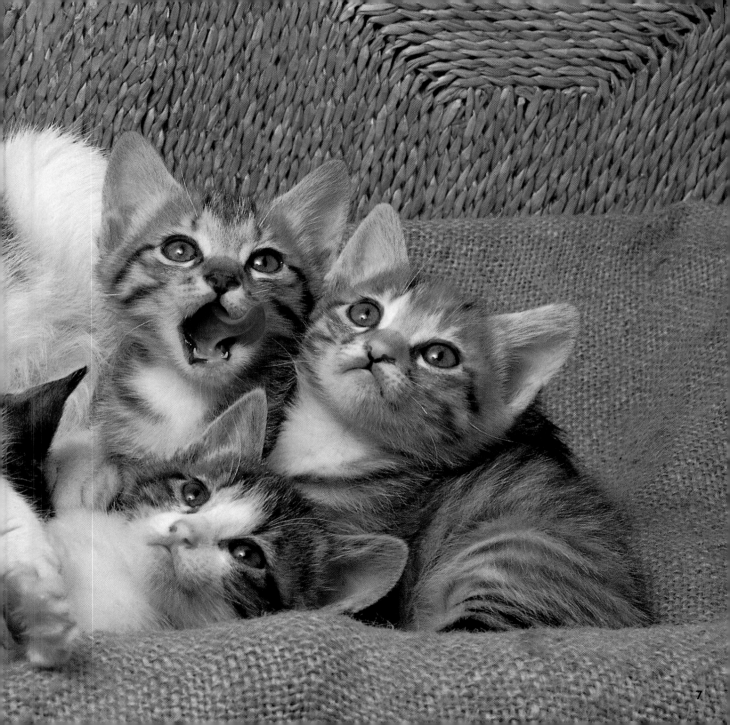

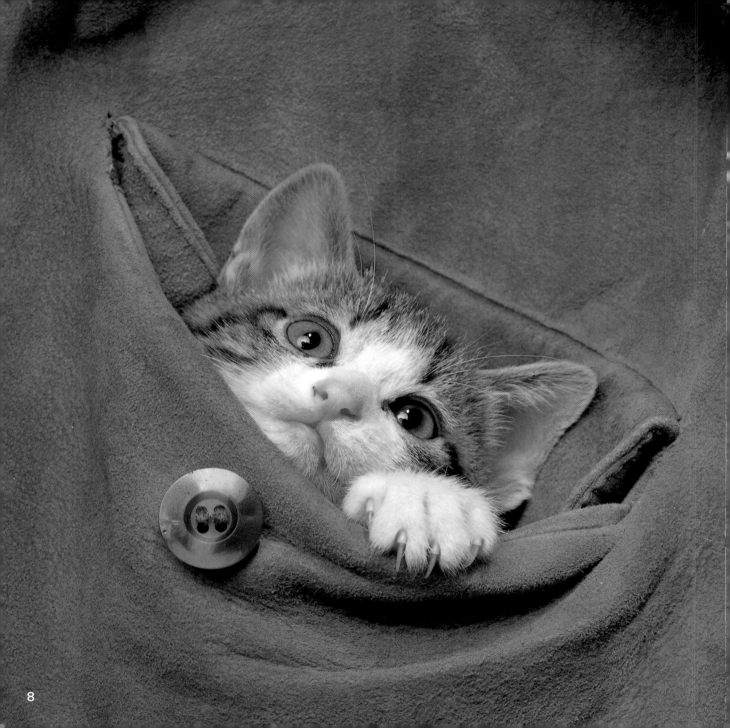

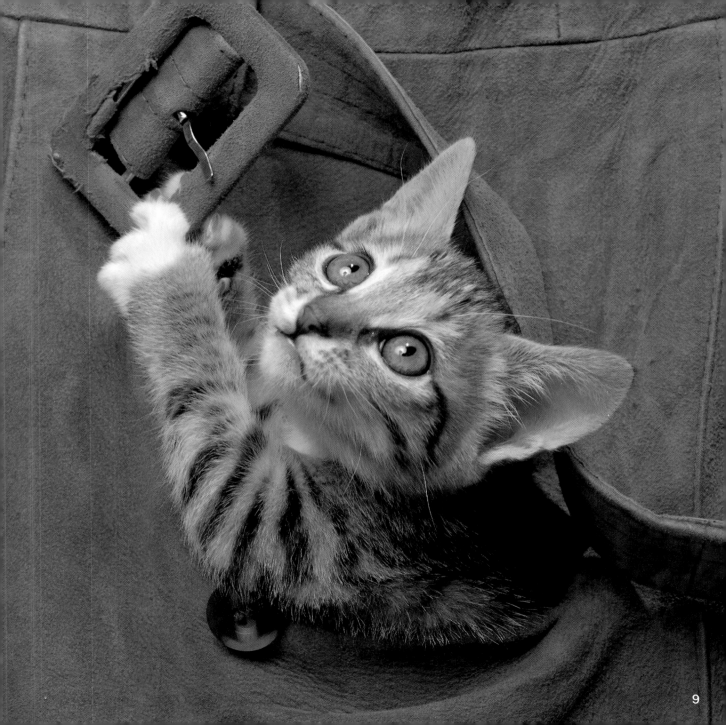

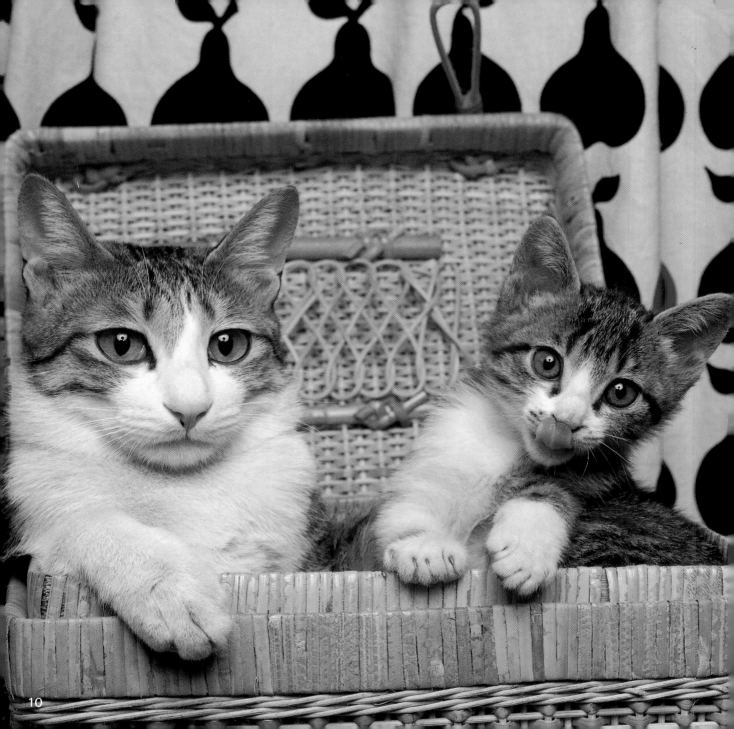

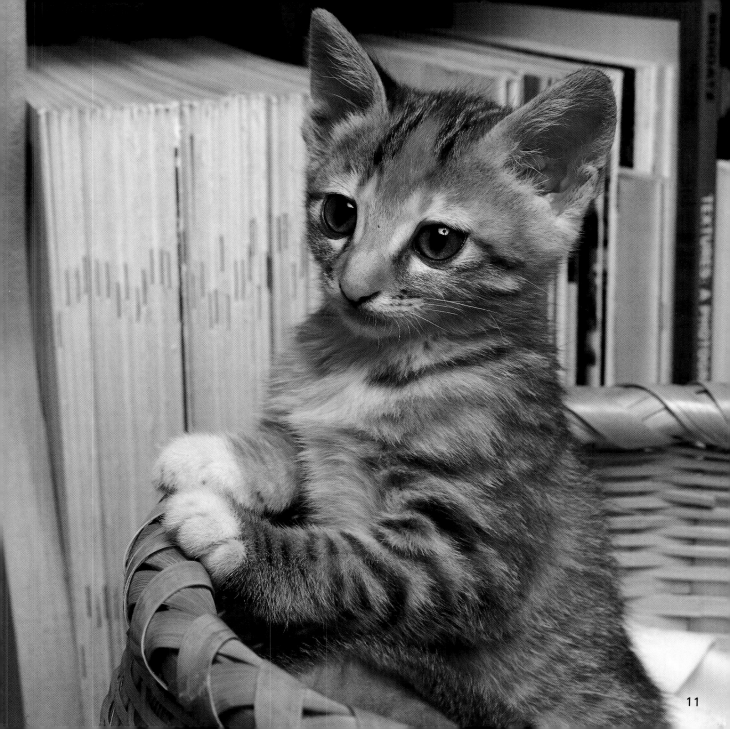

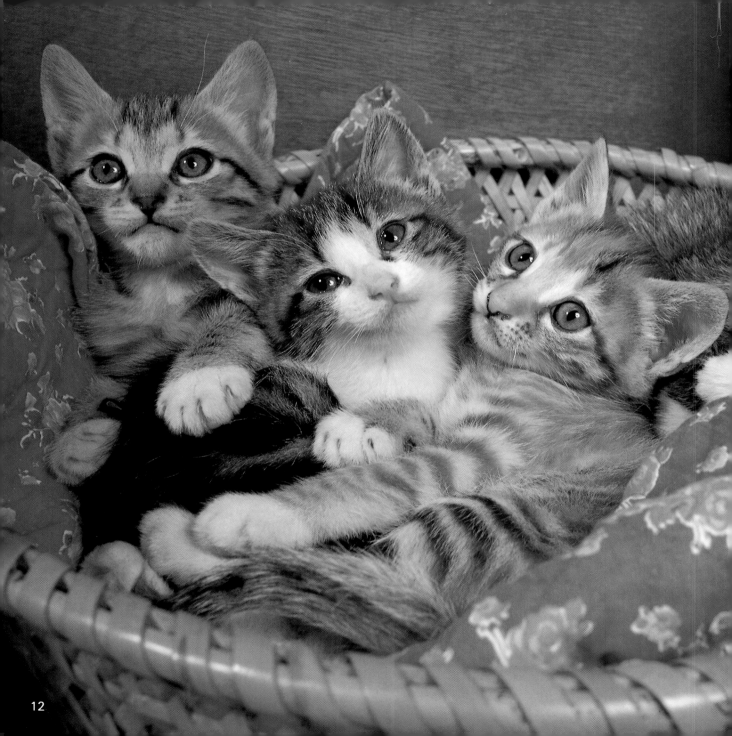

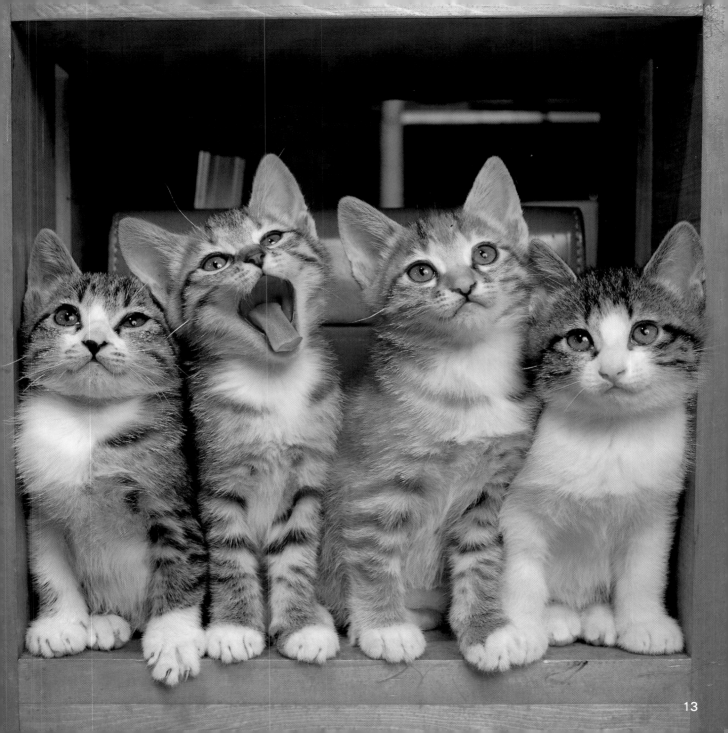

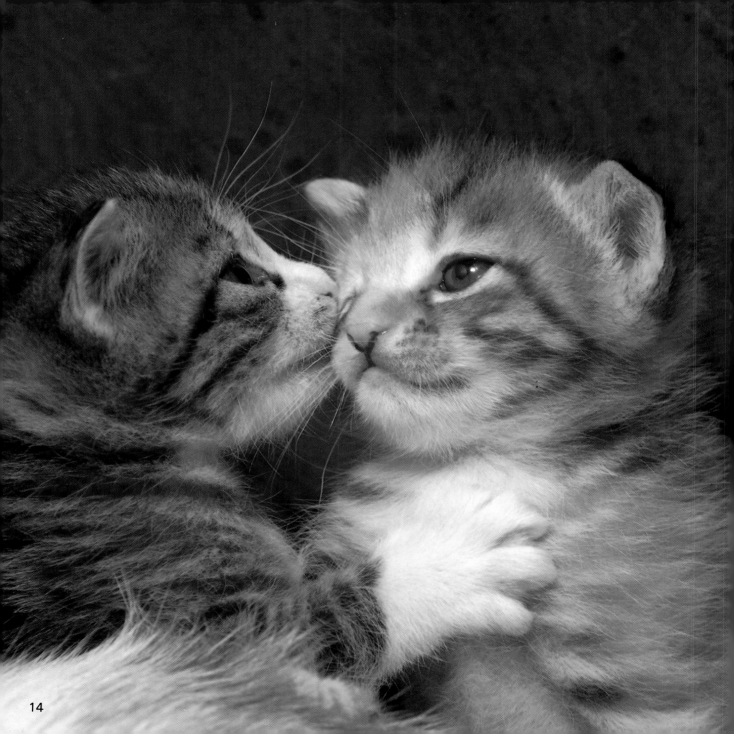

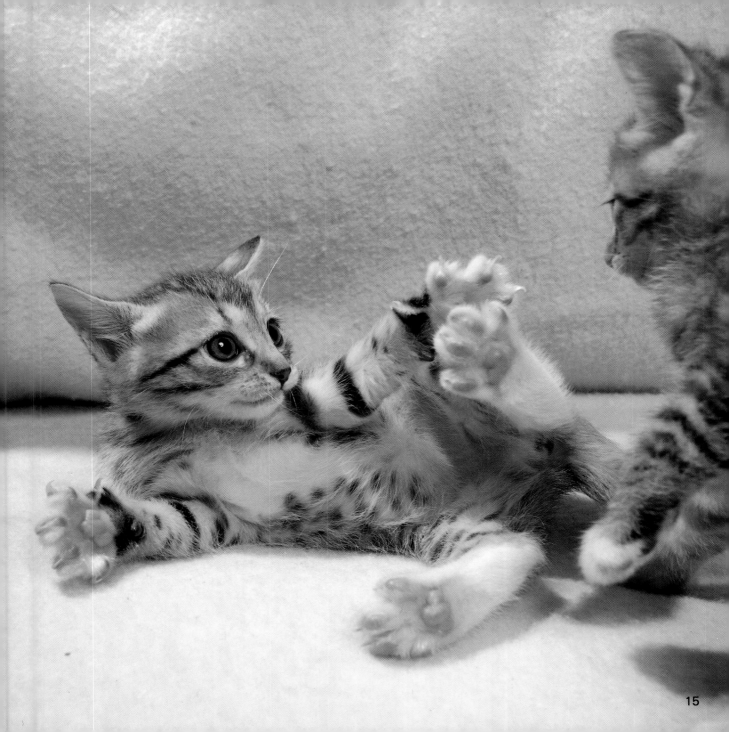

15

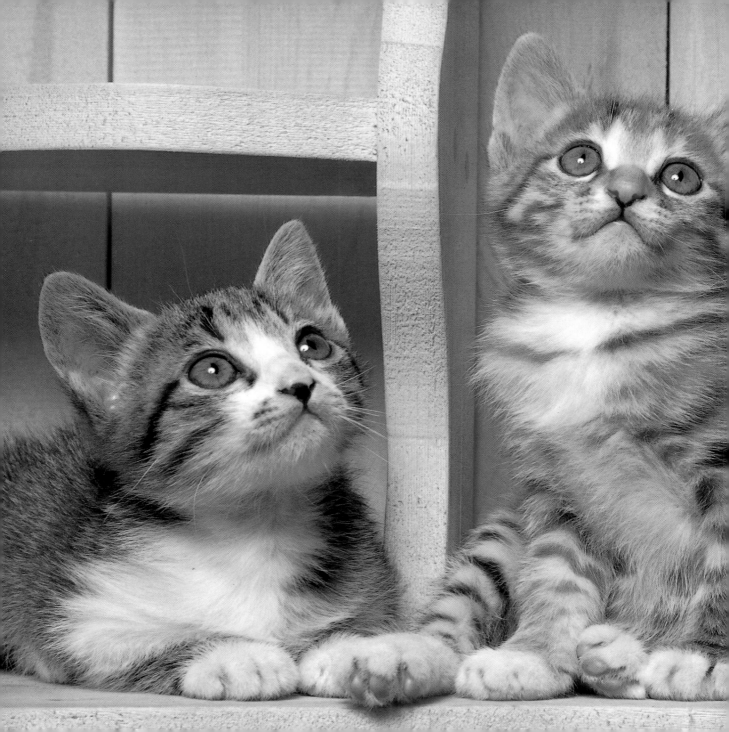

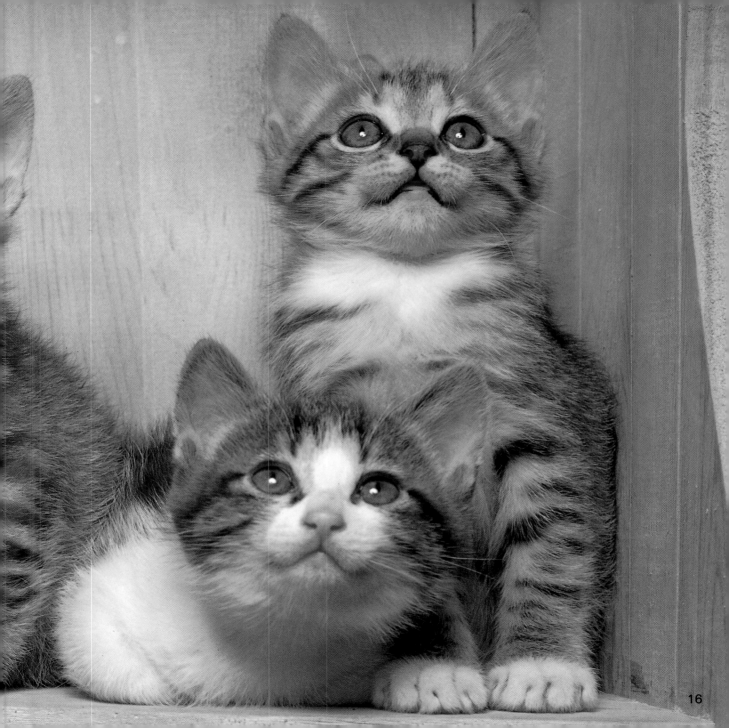

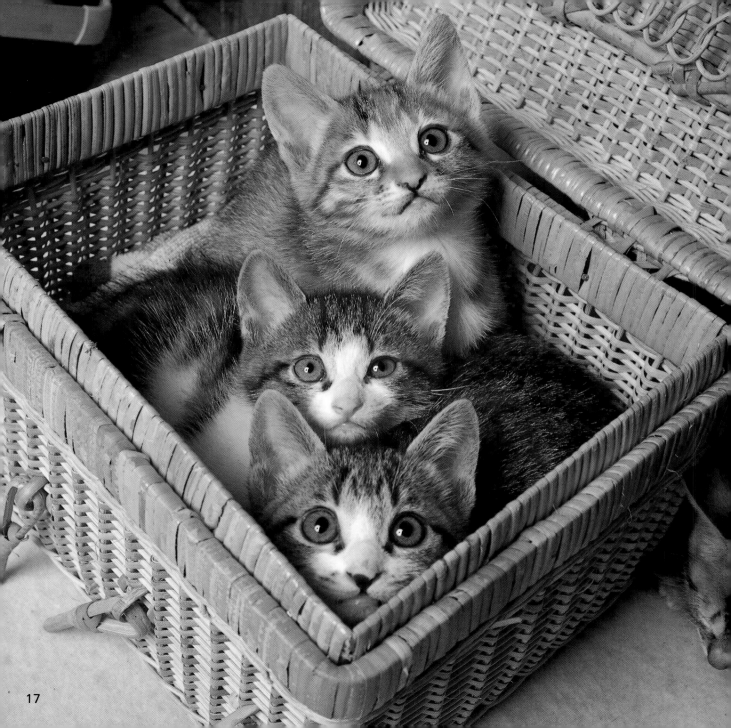

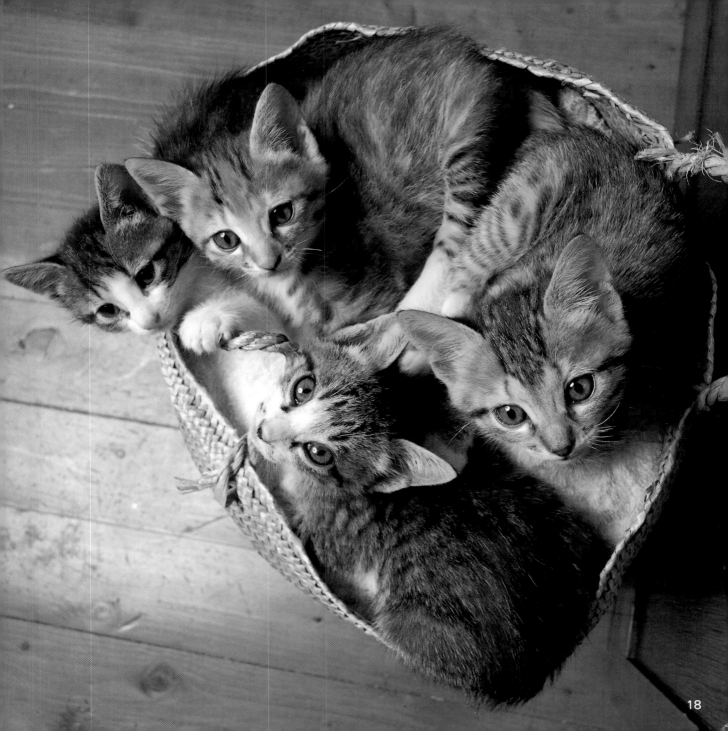

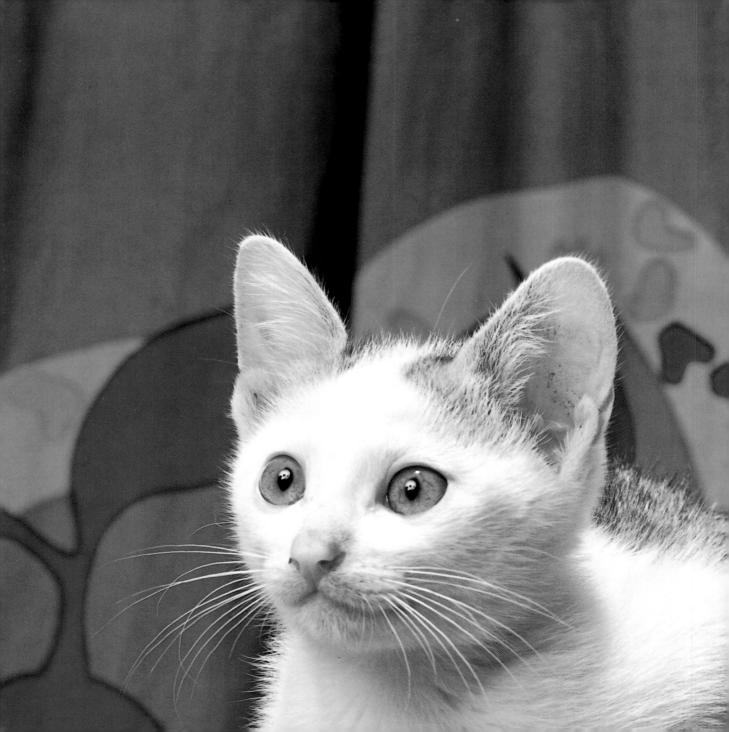

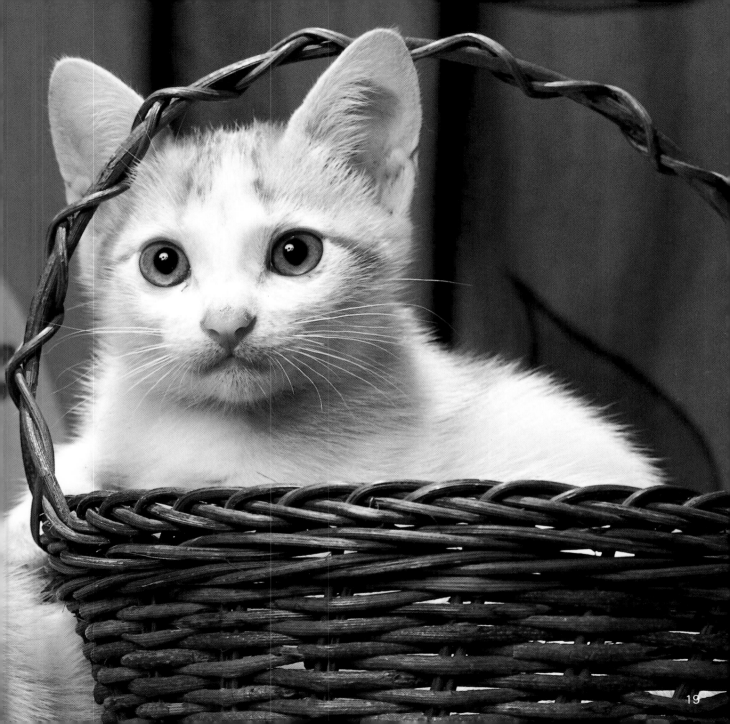

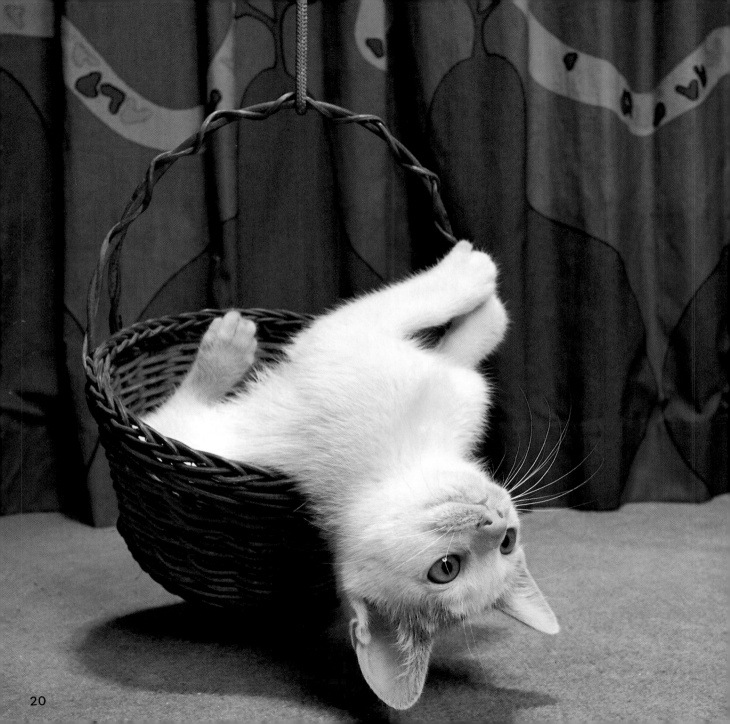

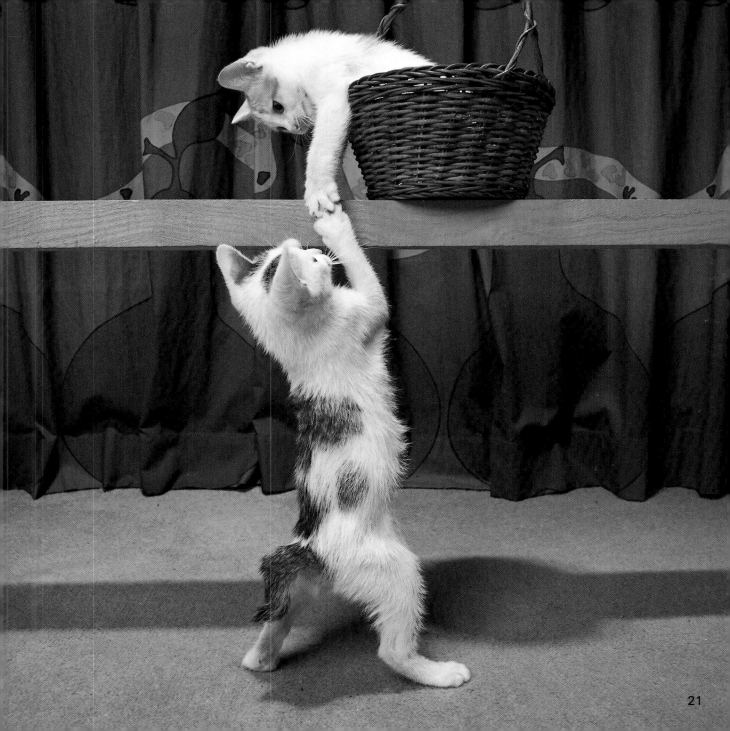

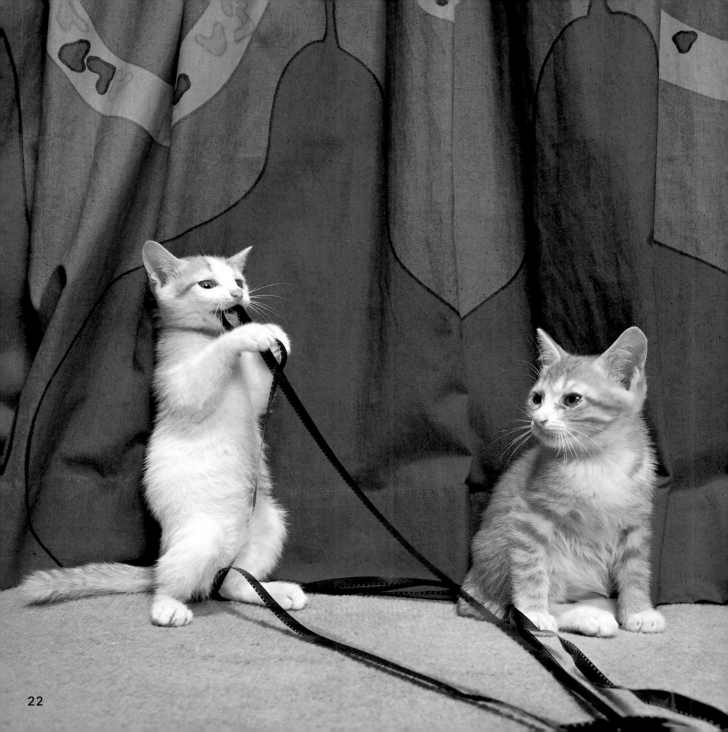

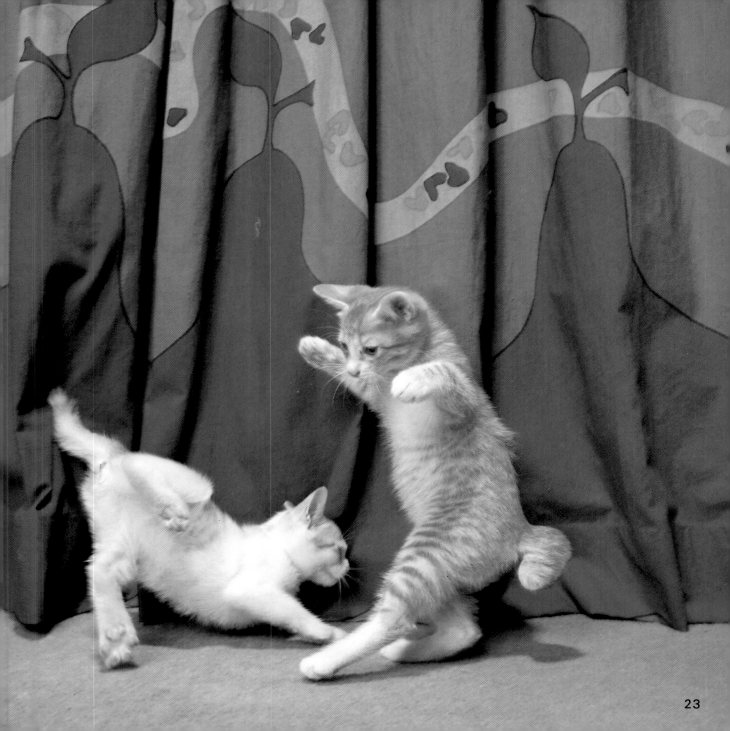

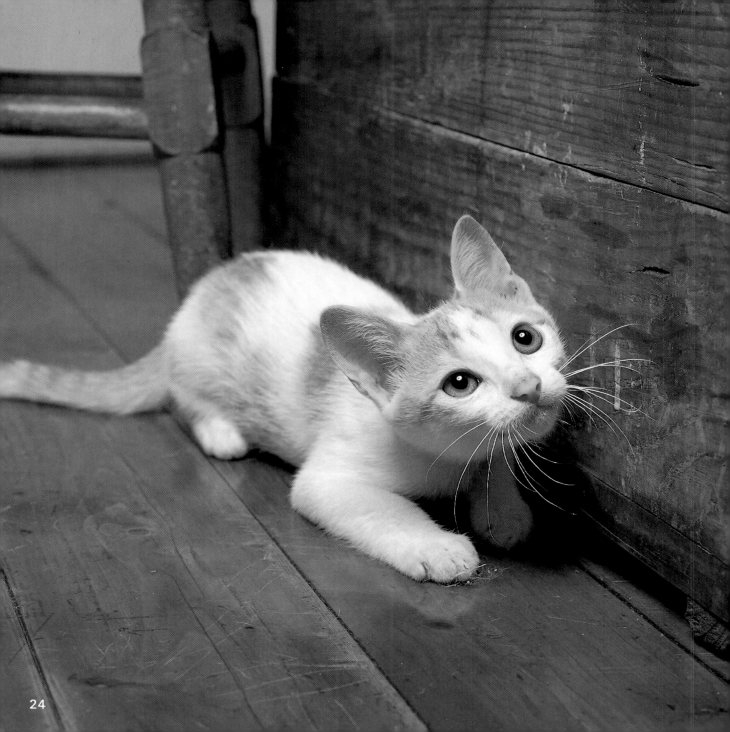

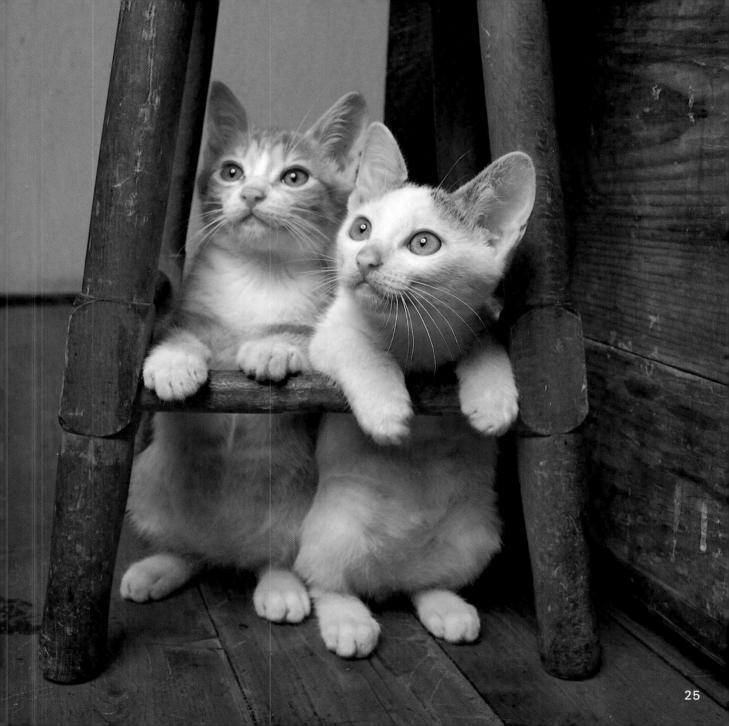

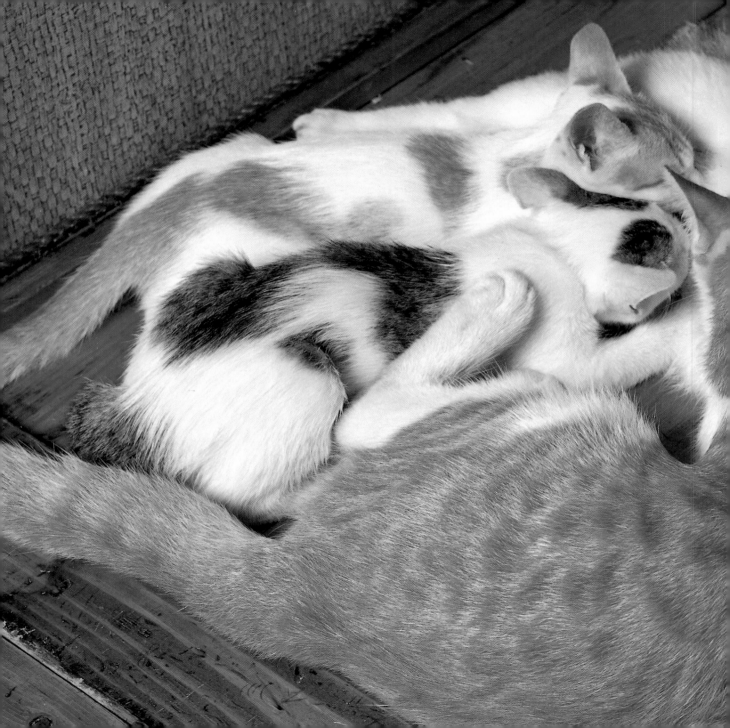

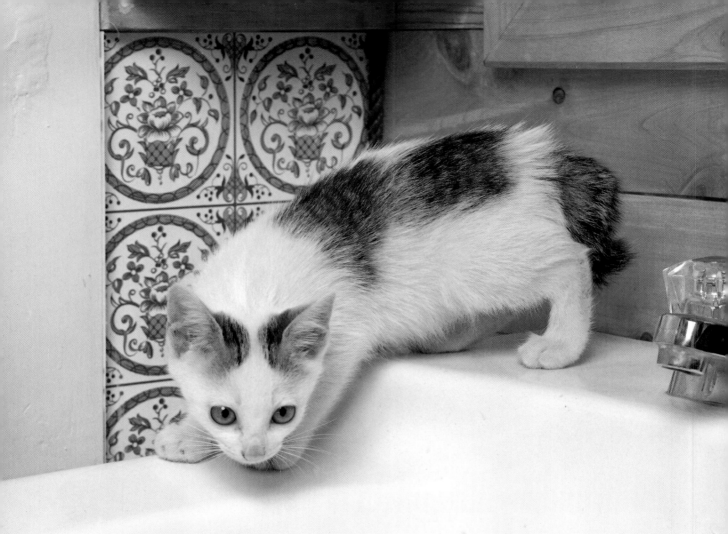

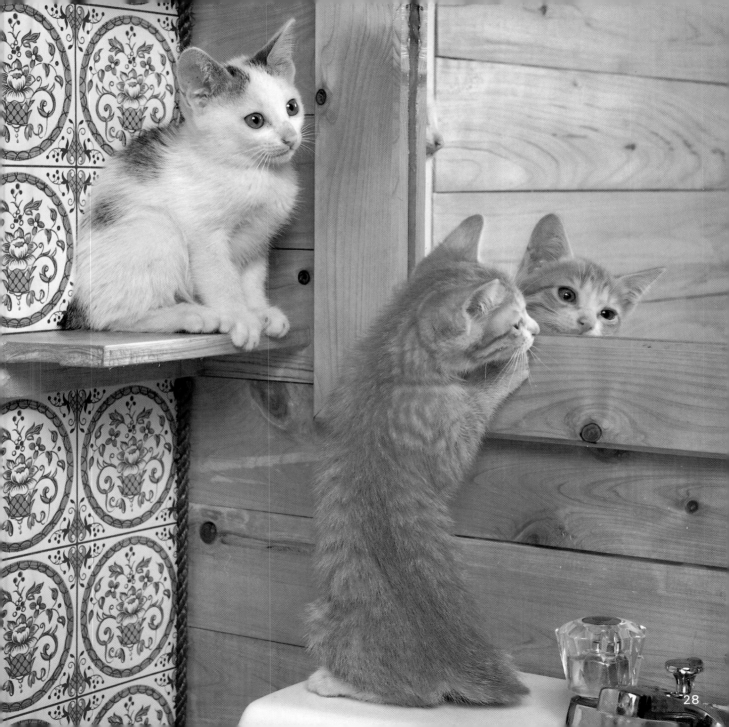

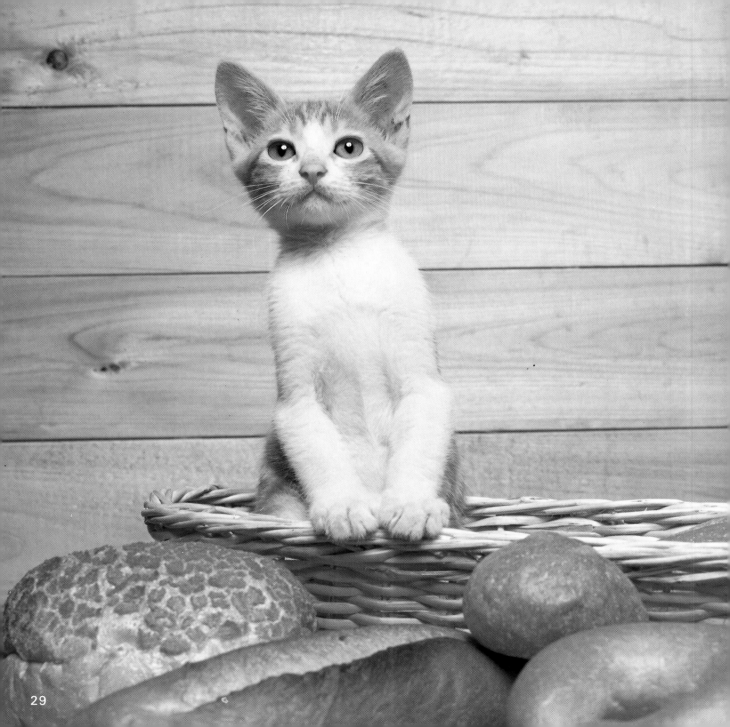

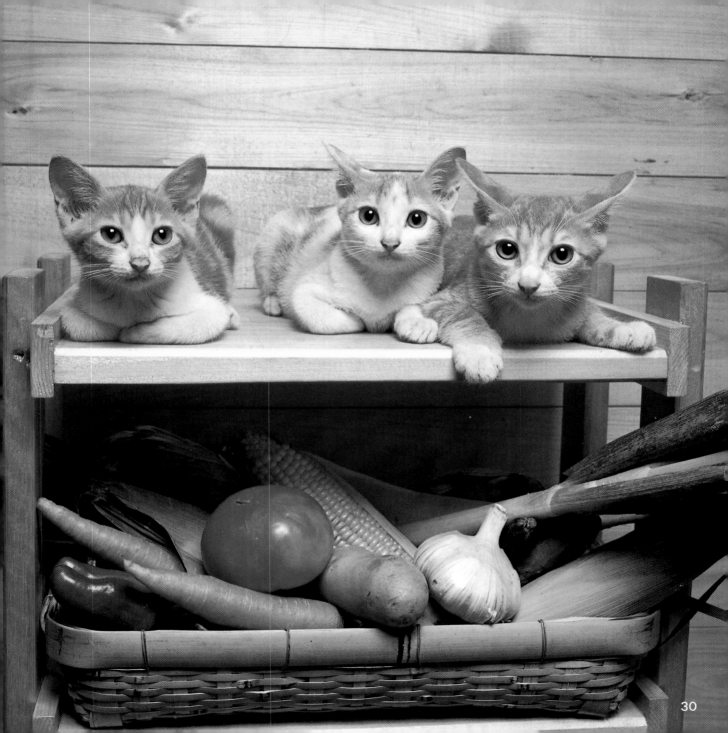

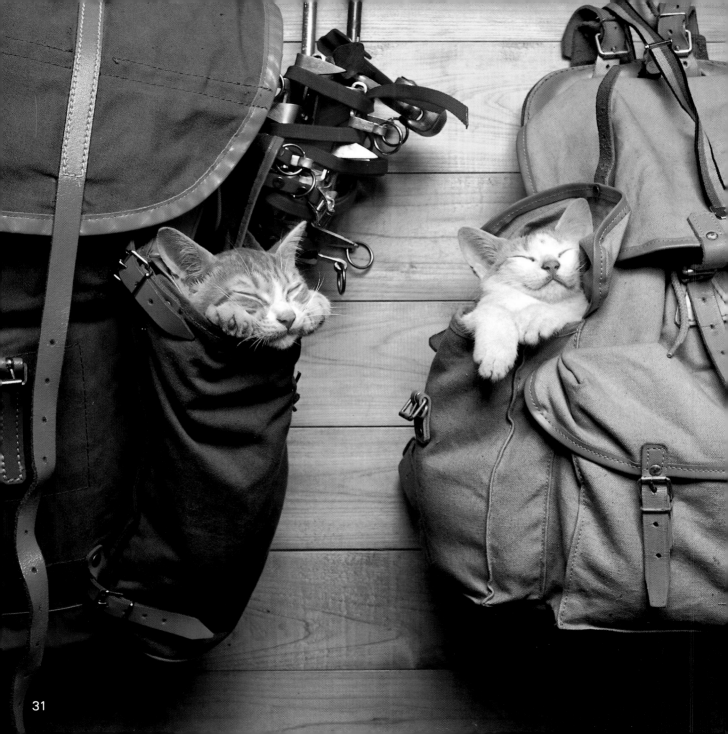

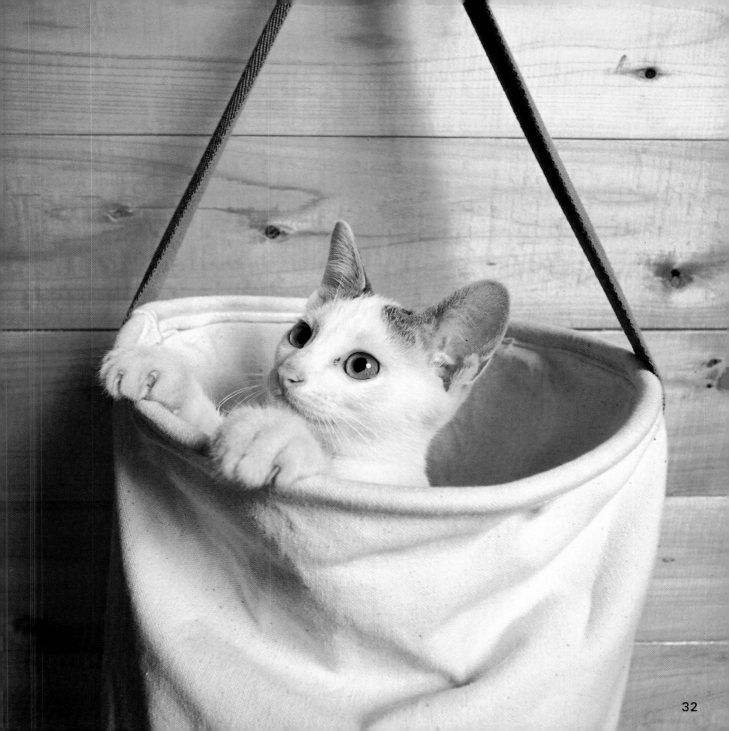

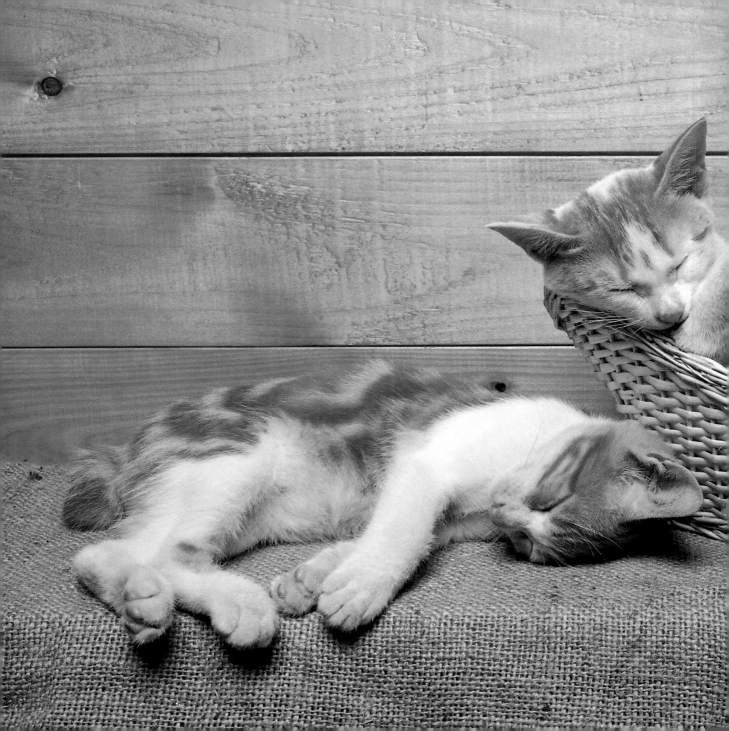

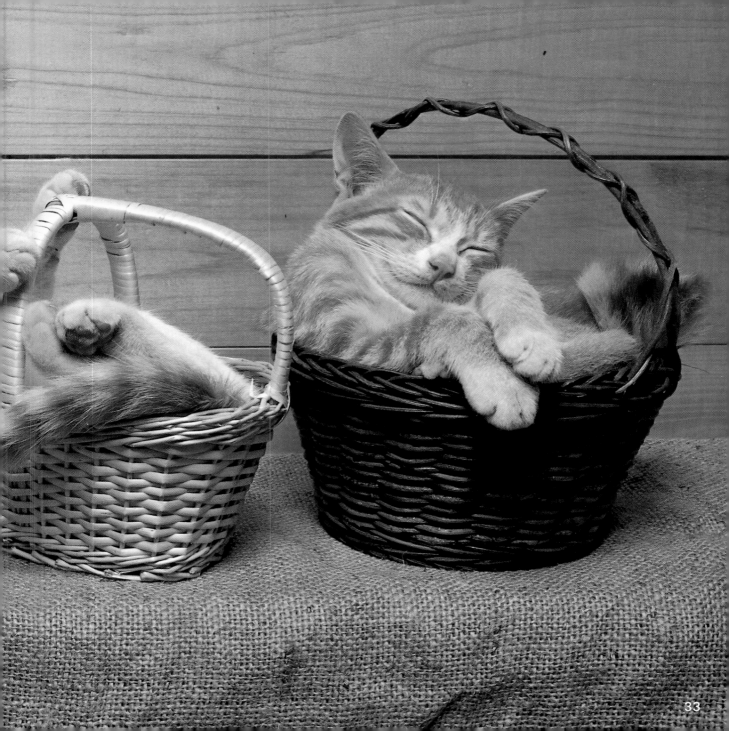

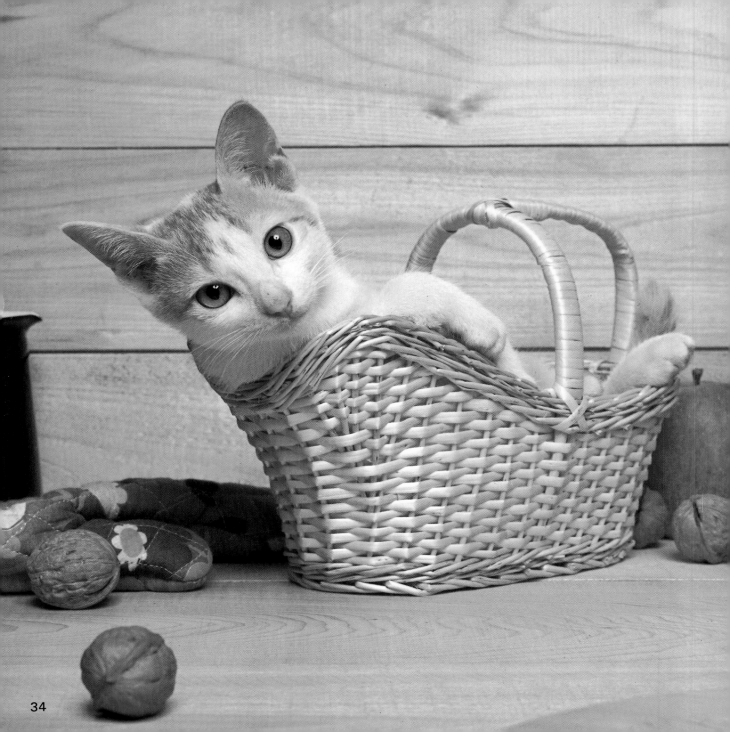

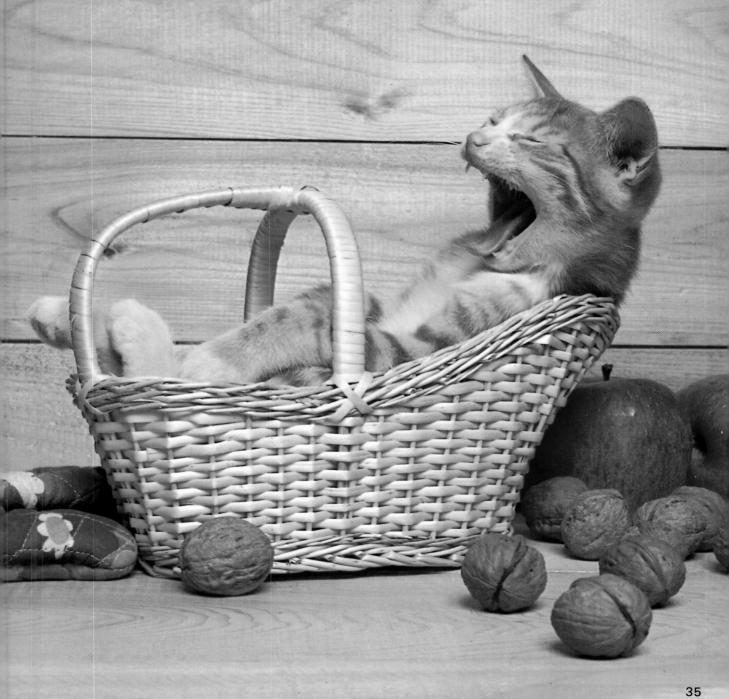

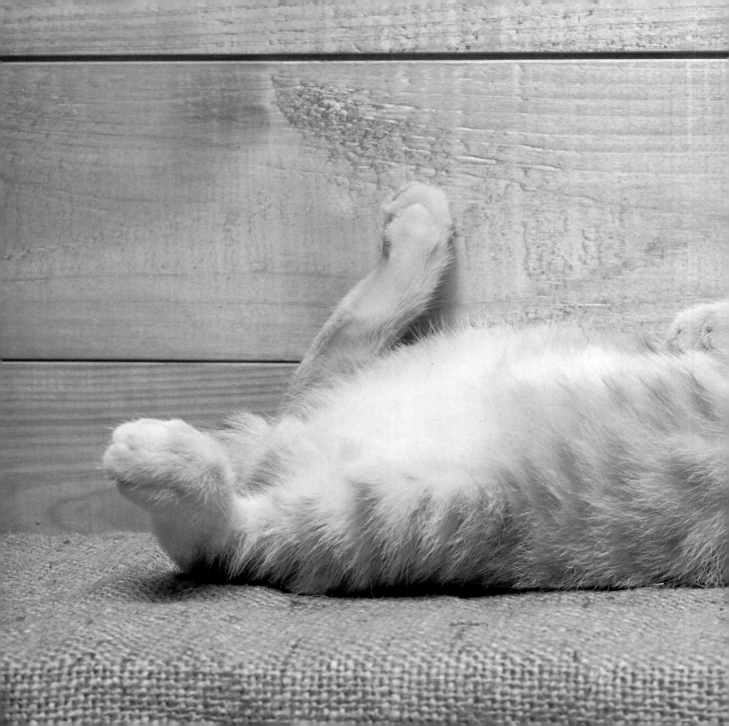

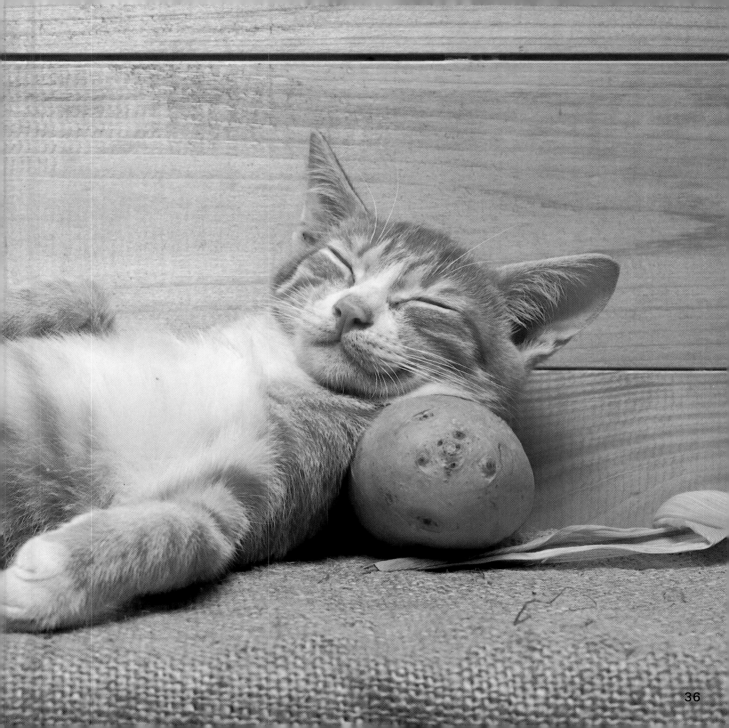

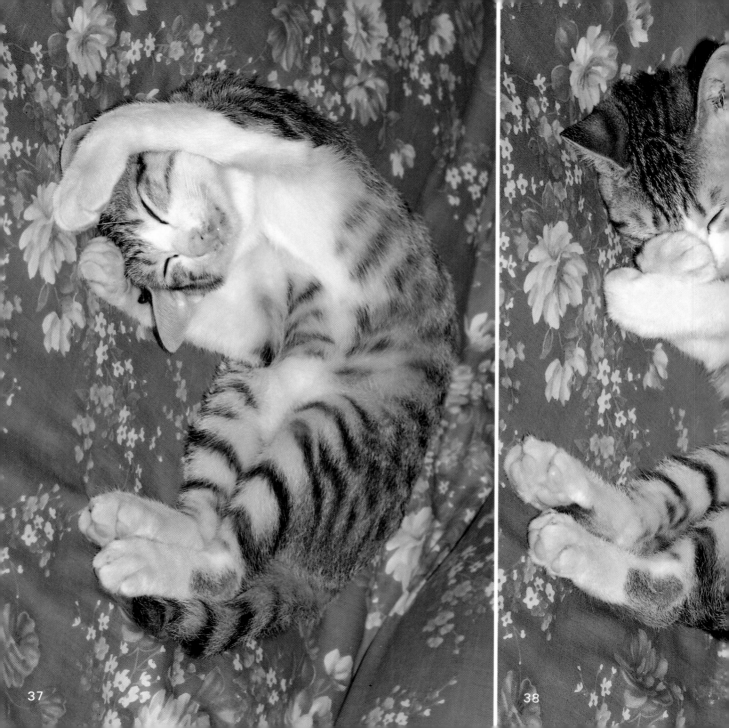

37

38

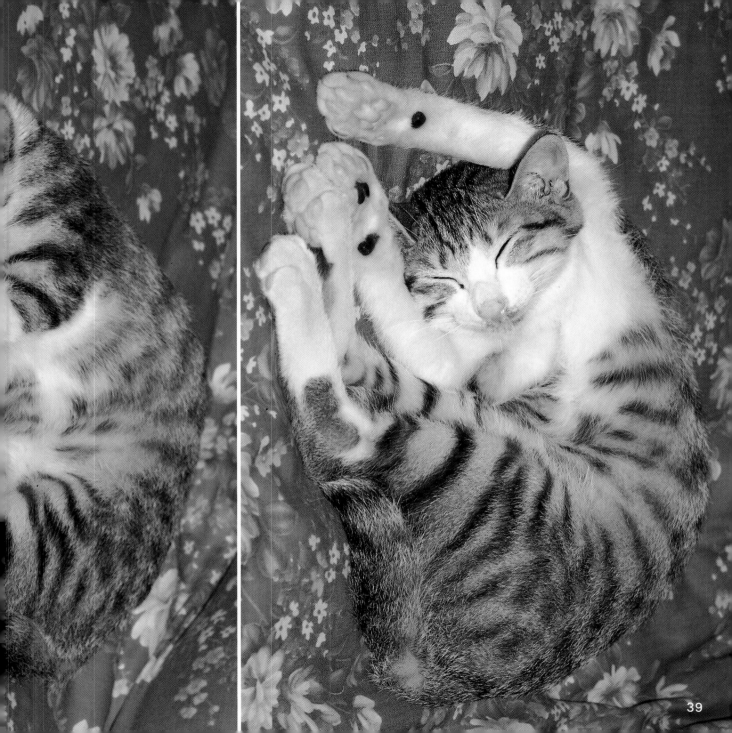

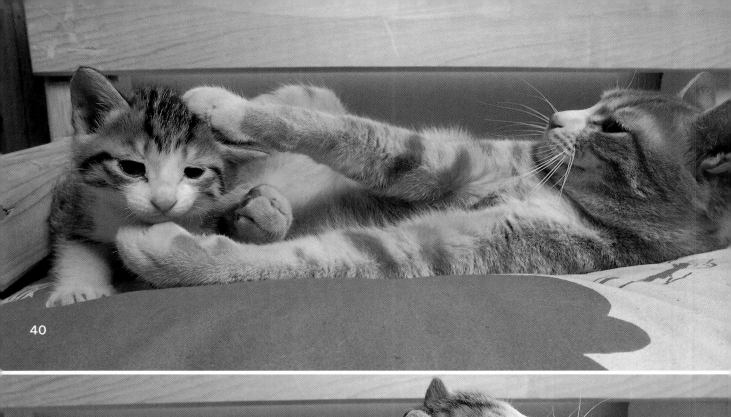

40

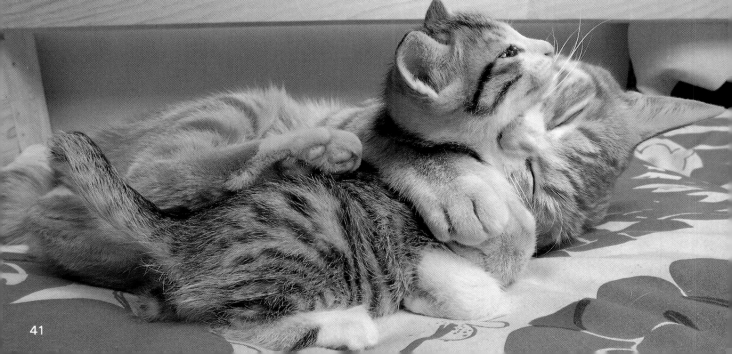

41

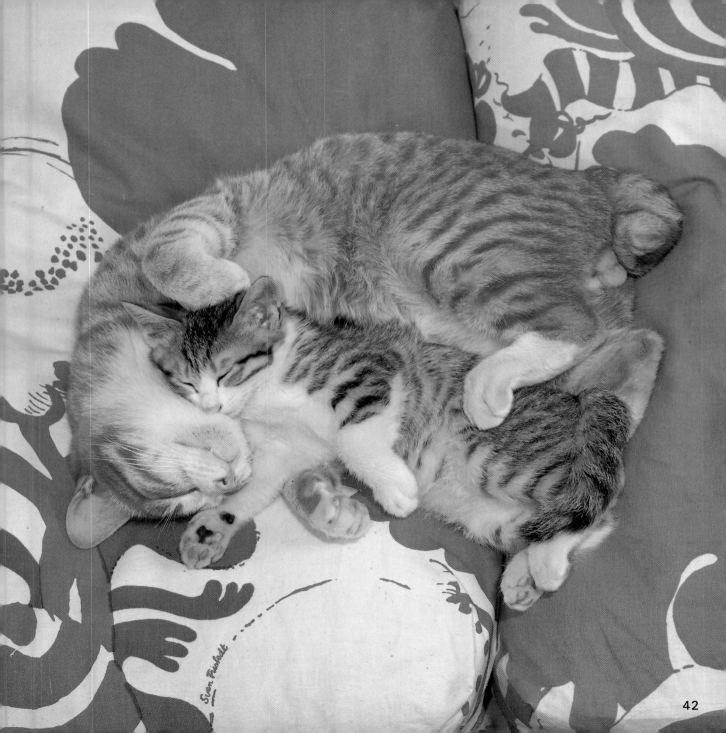

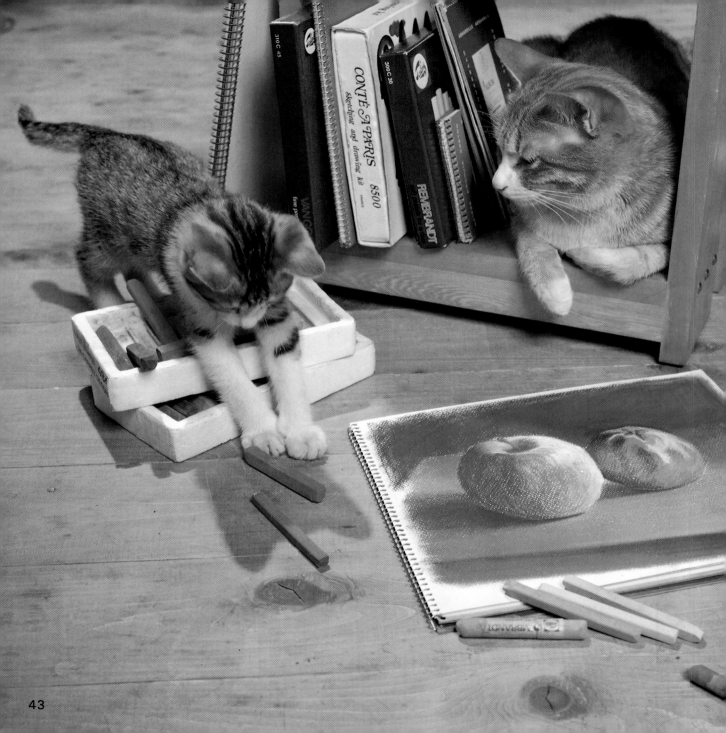

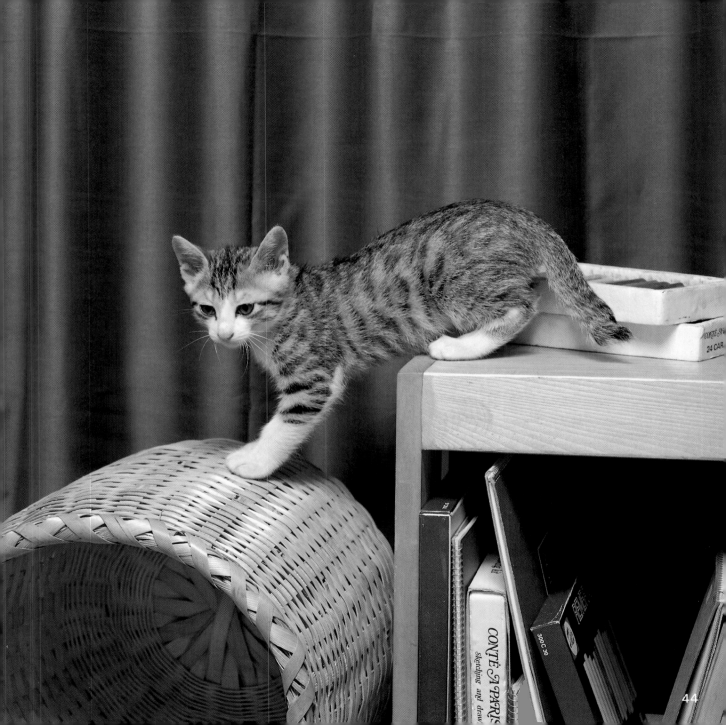

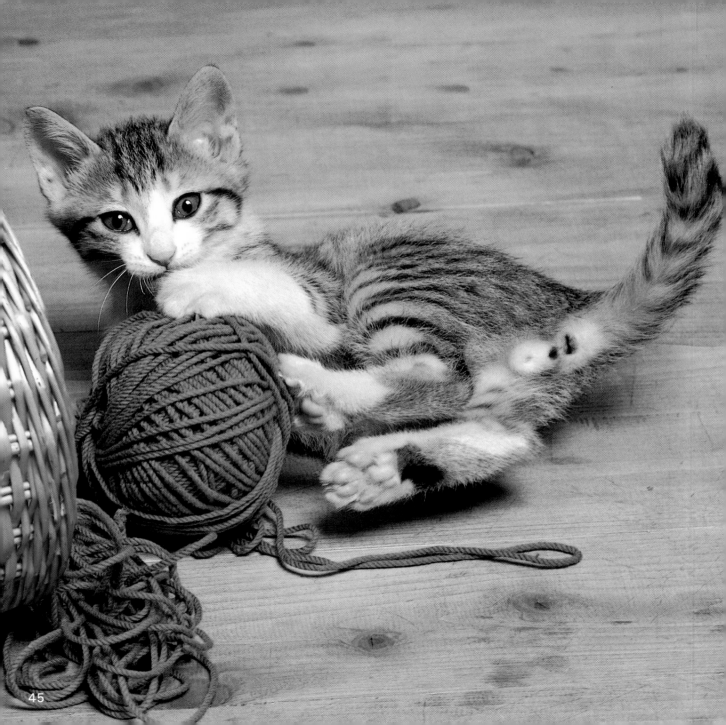

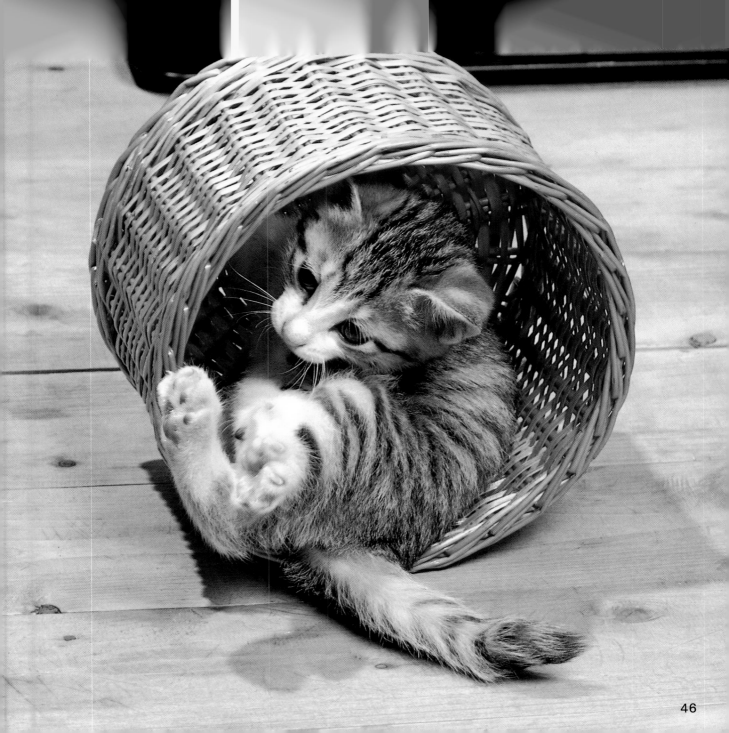

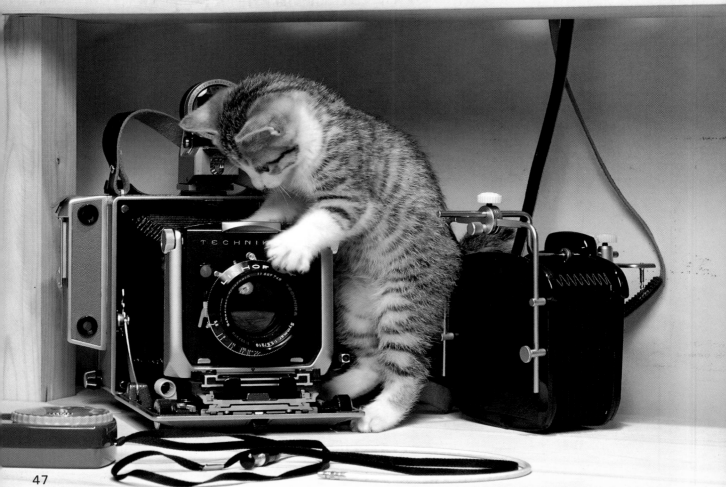

47

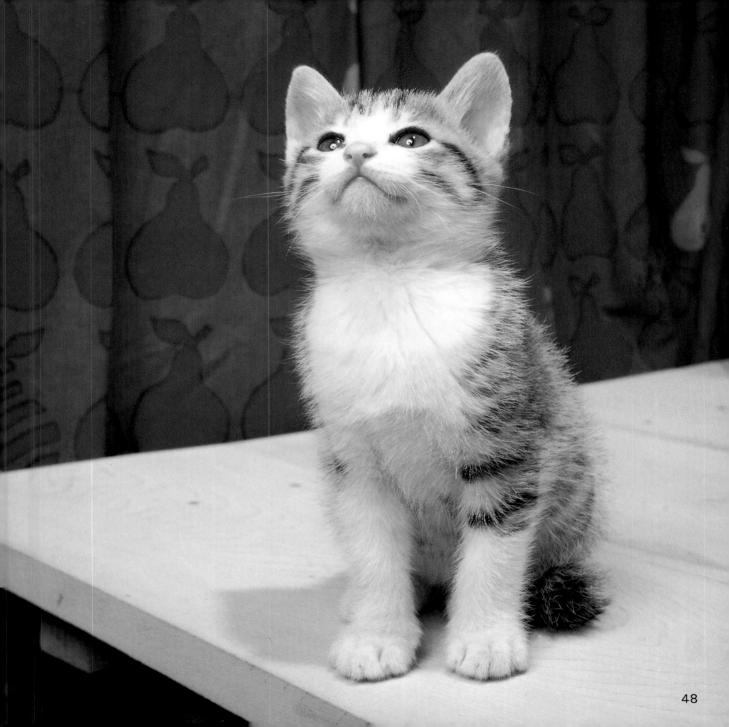

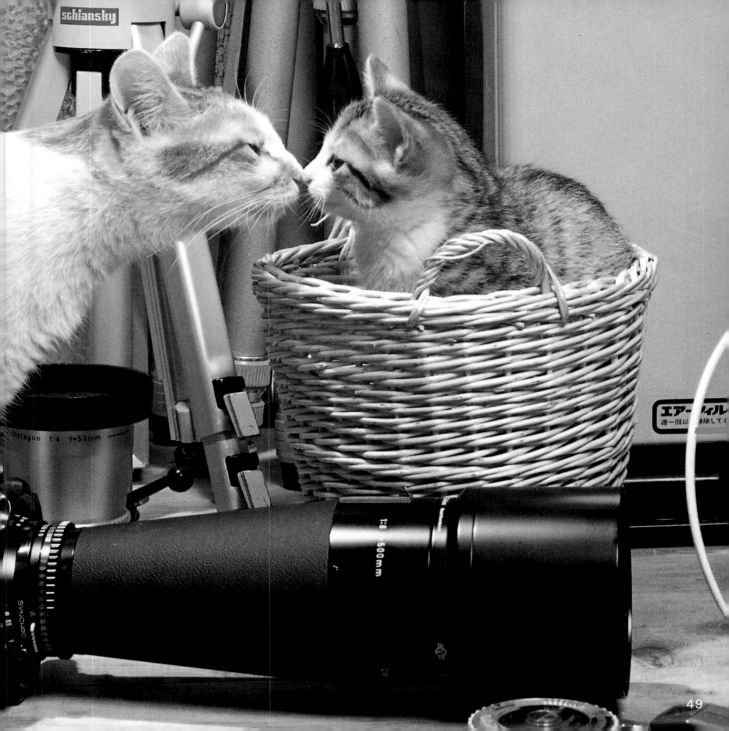

49

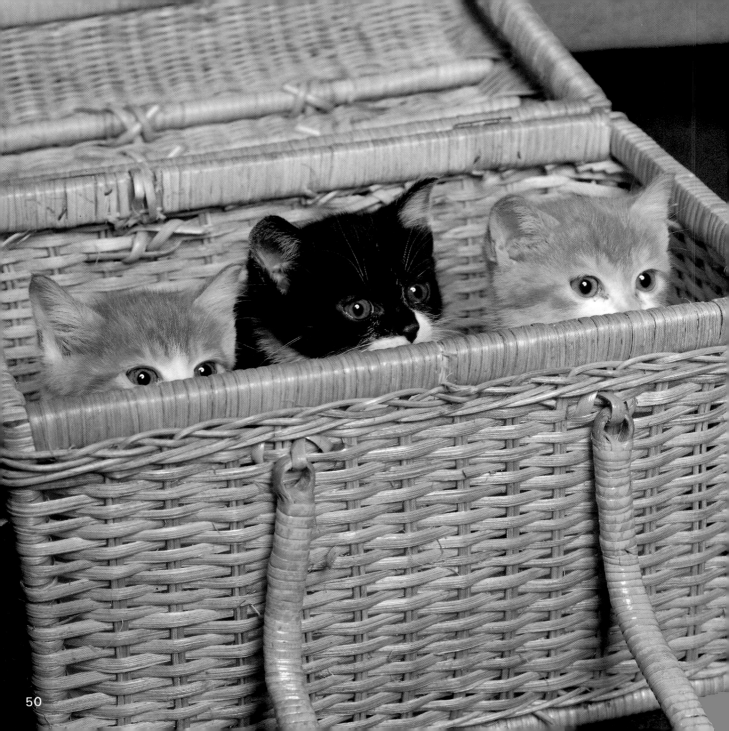

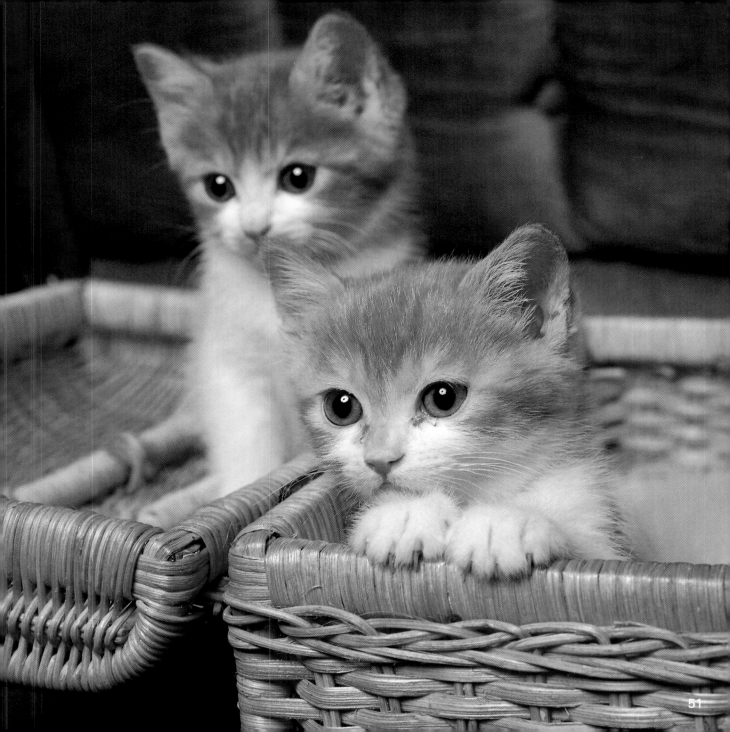

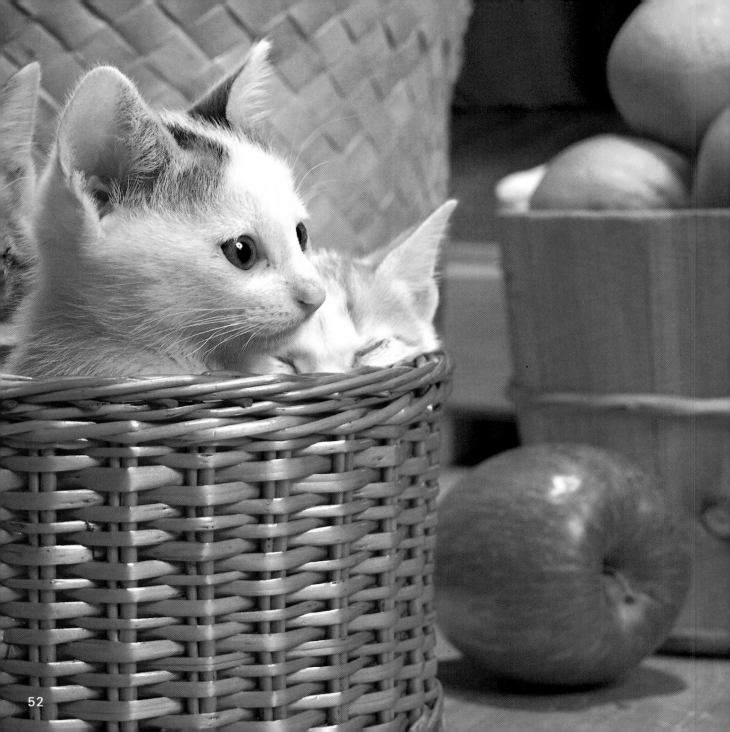

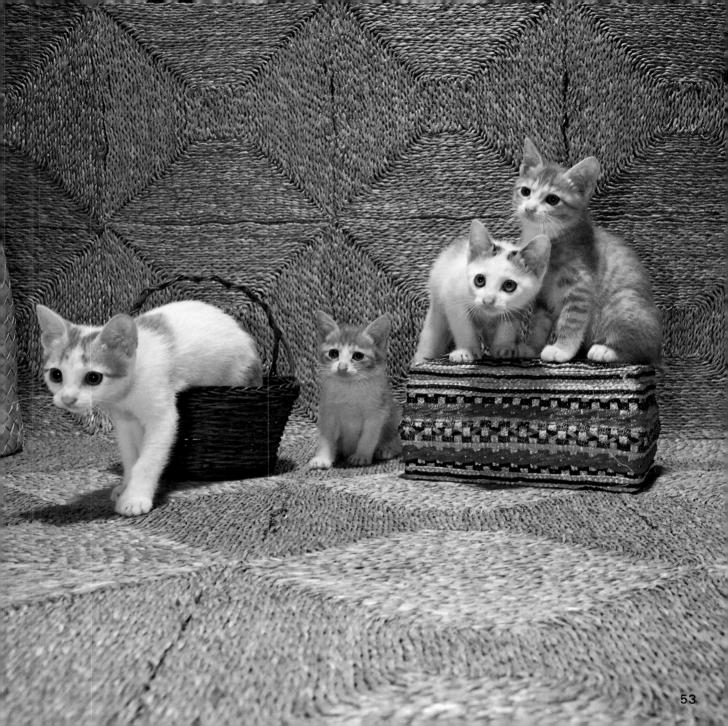

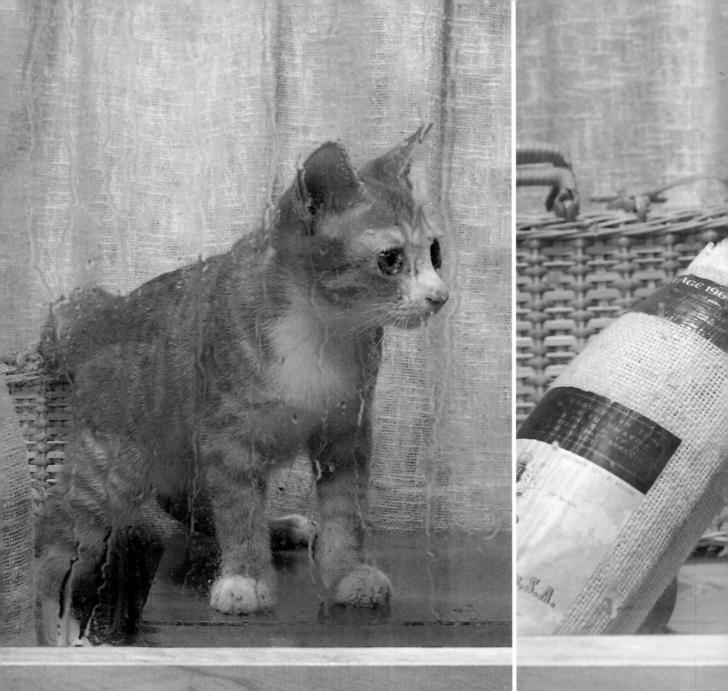

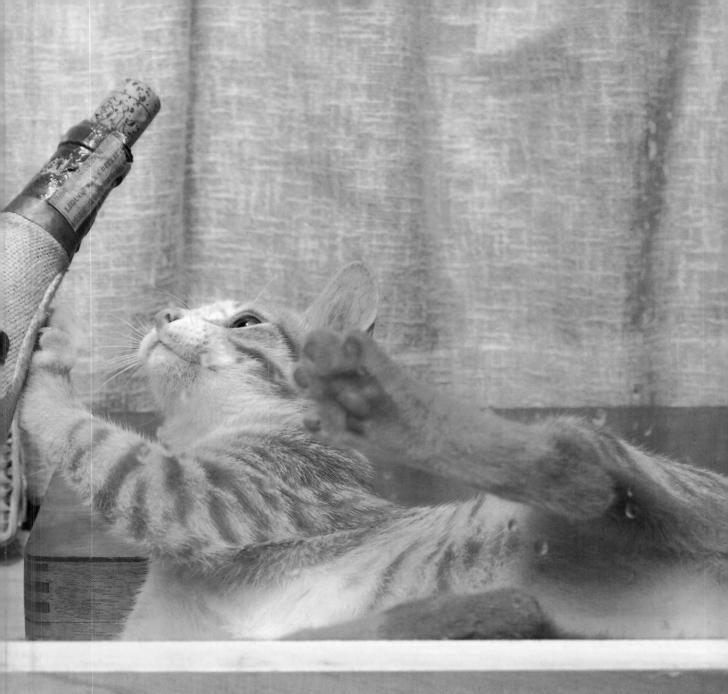

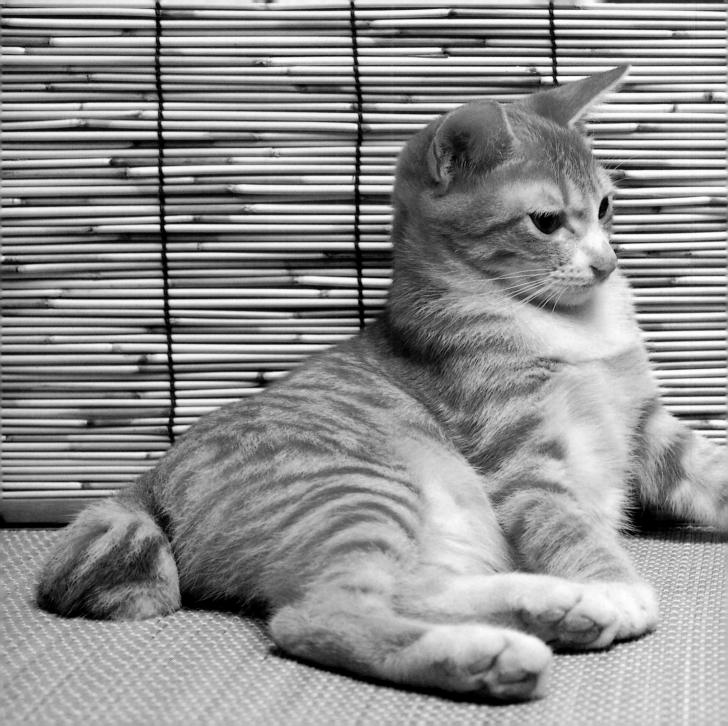

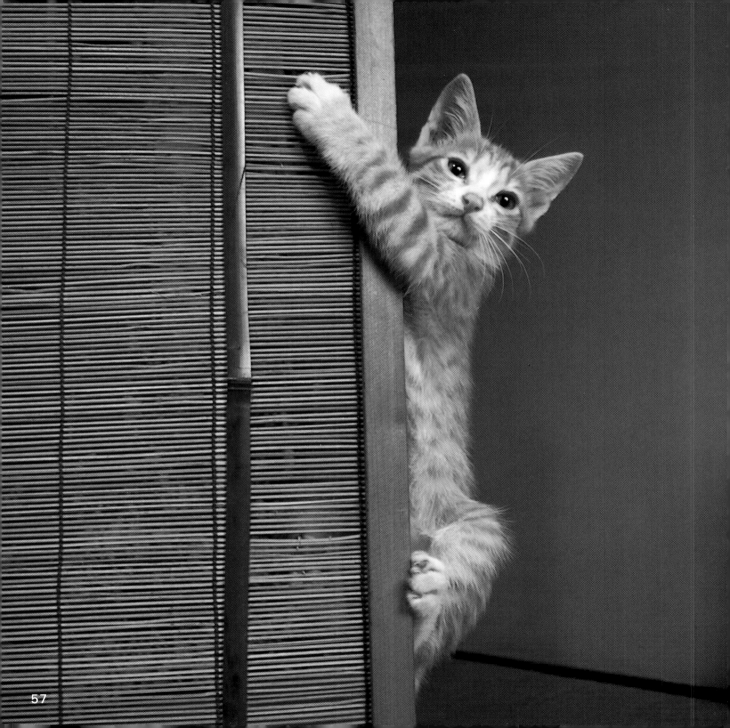

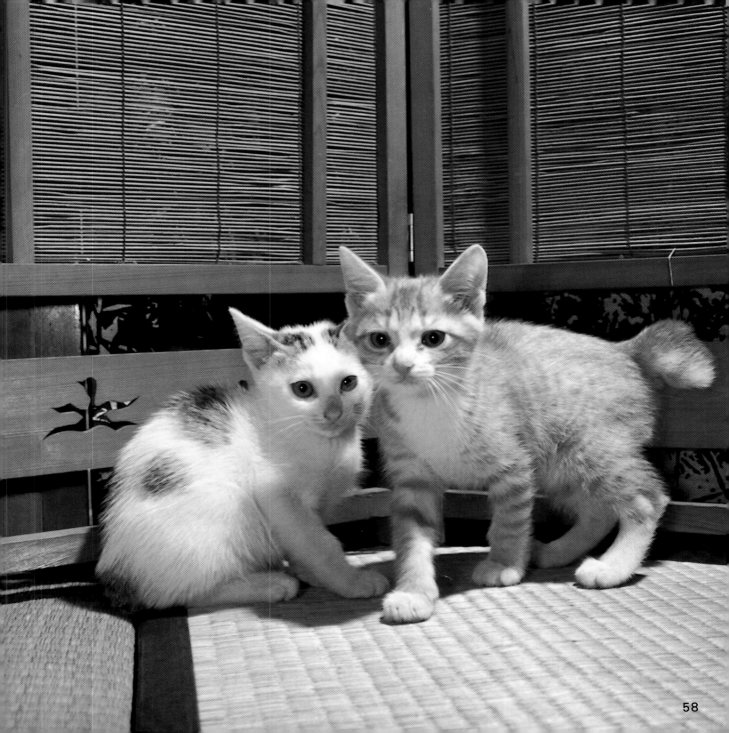

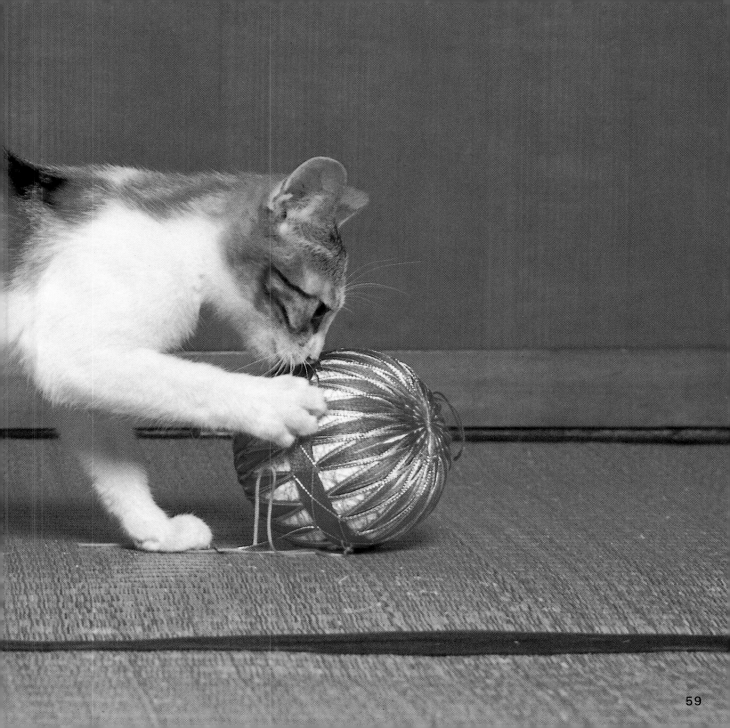

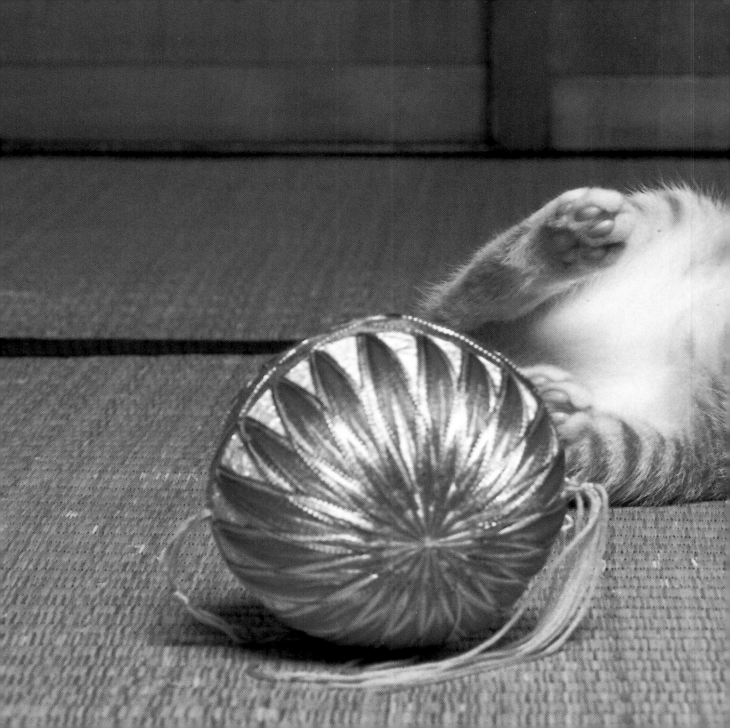

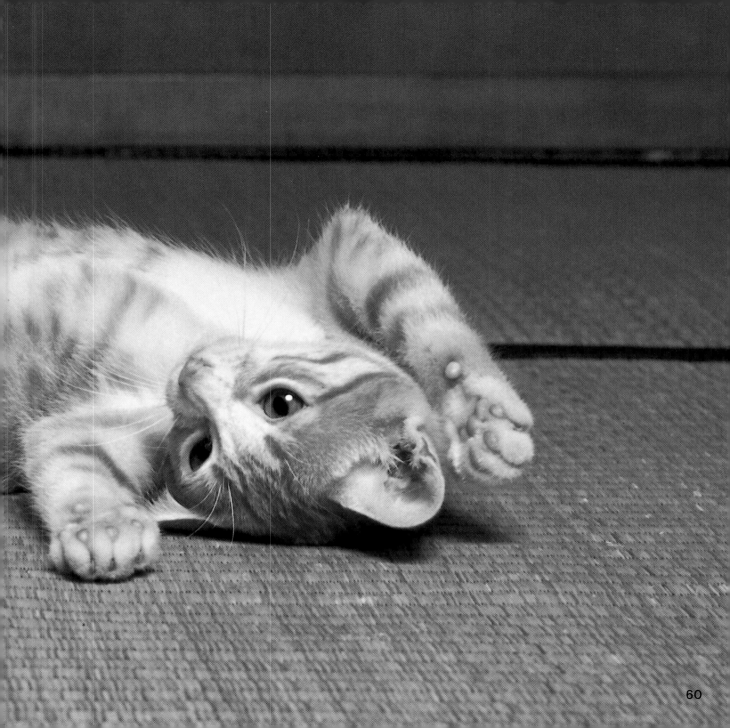

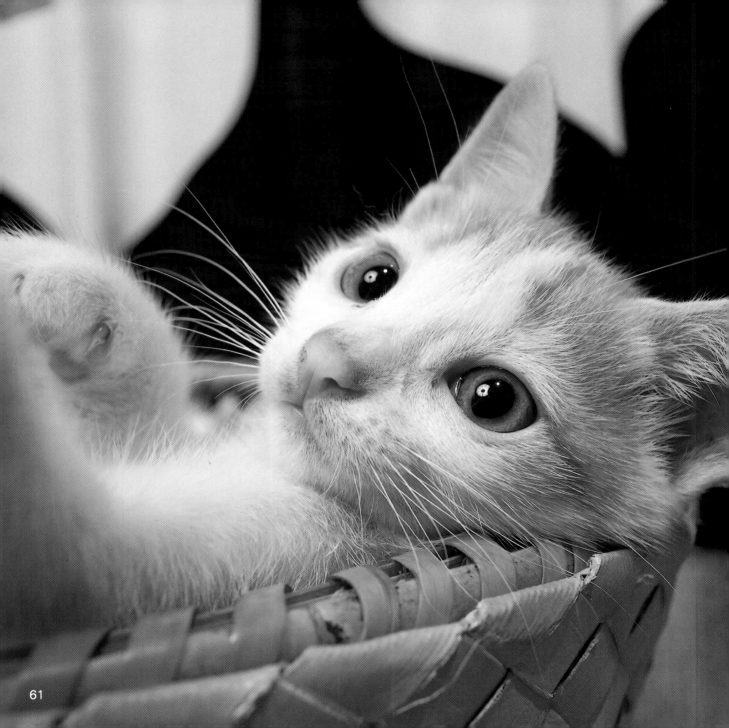

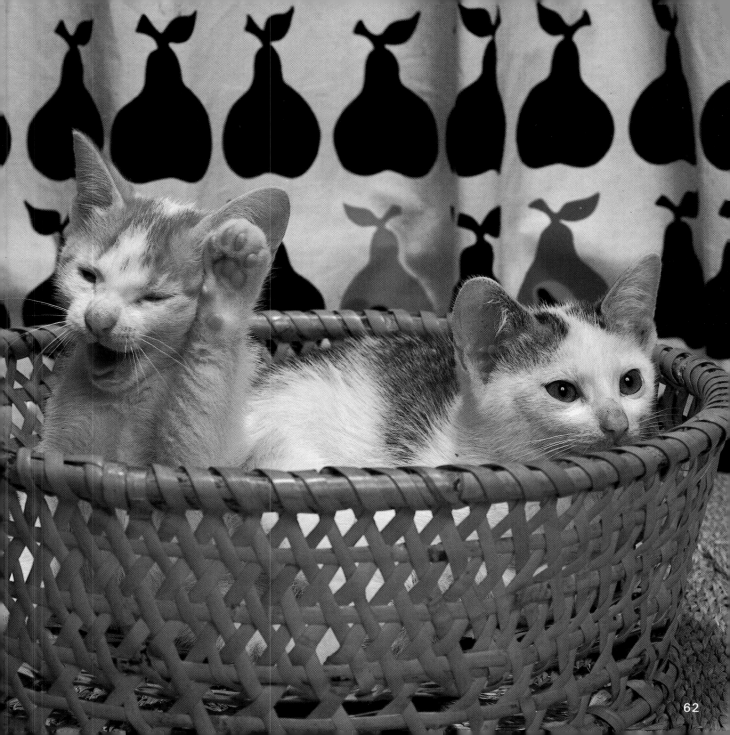

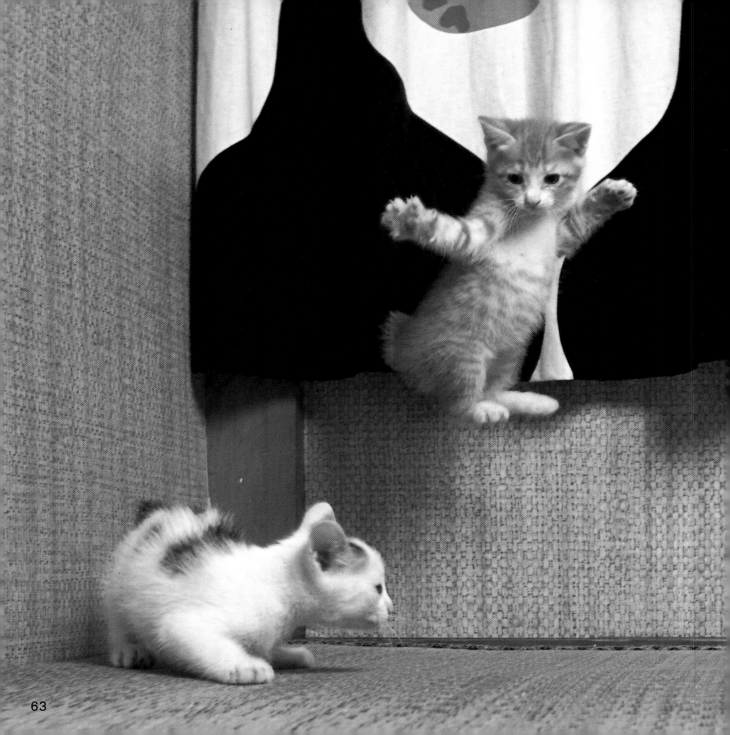

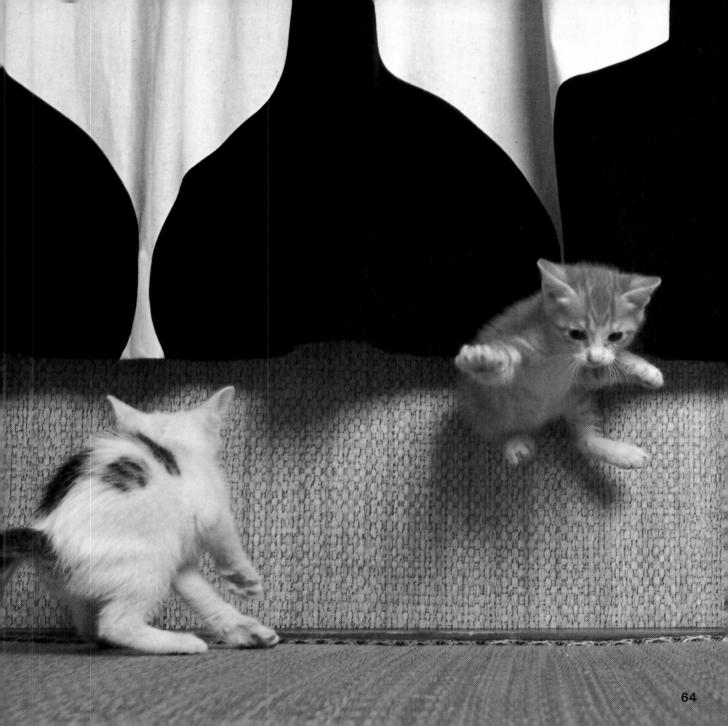

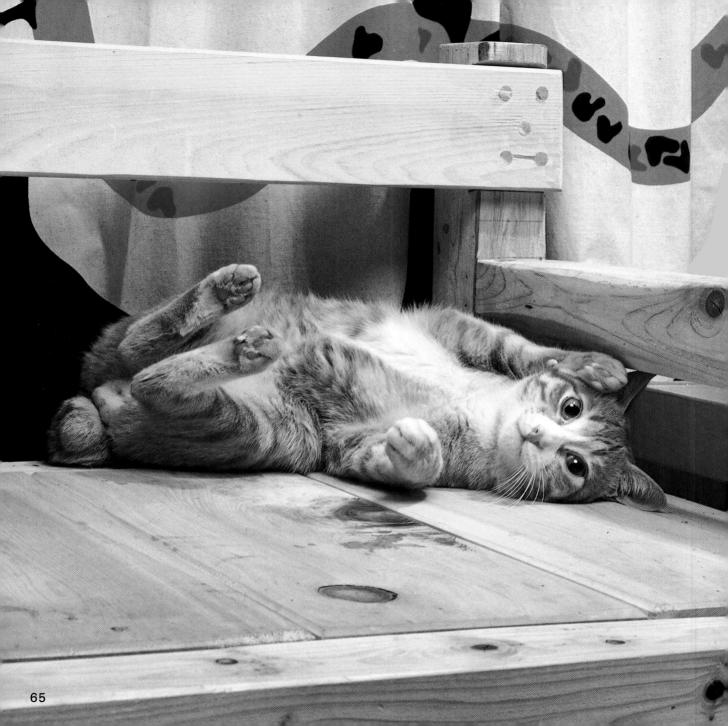

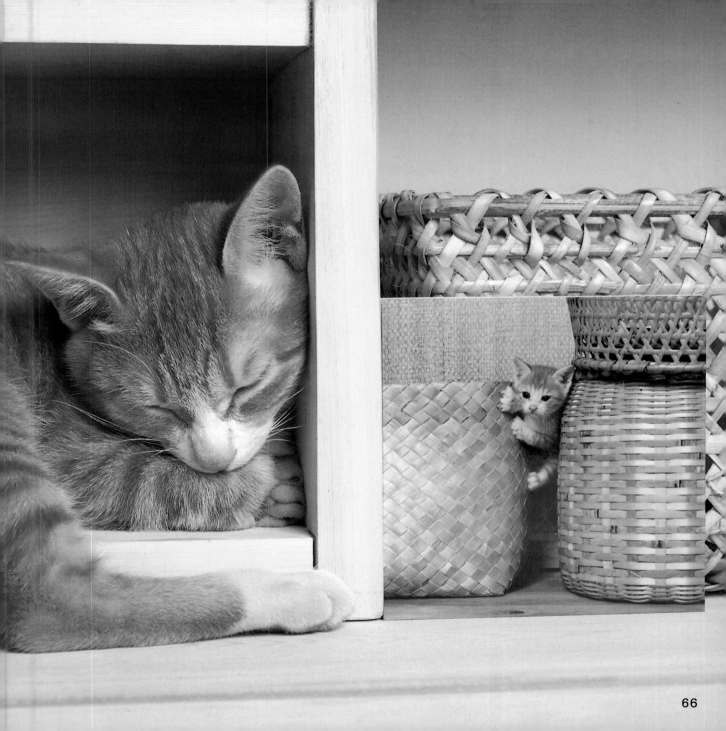

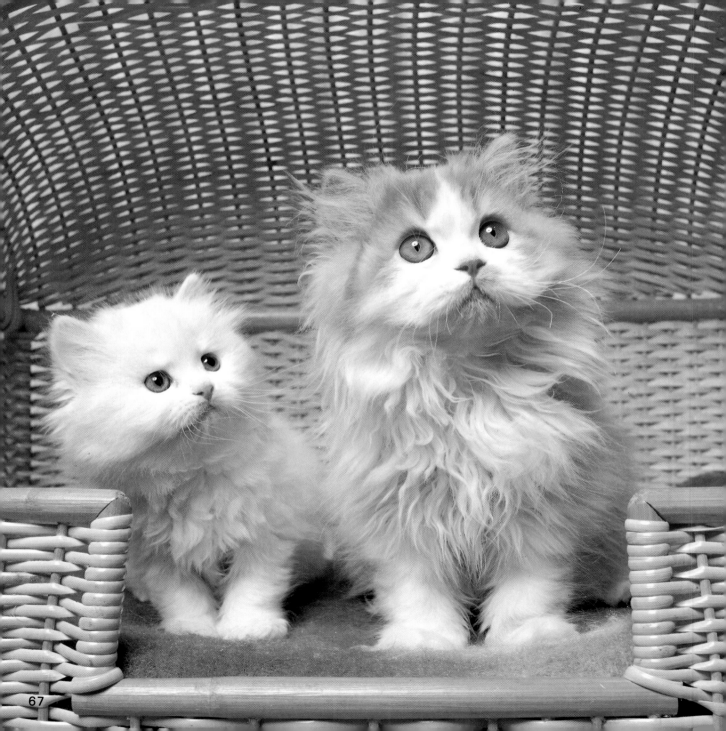

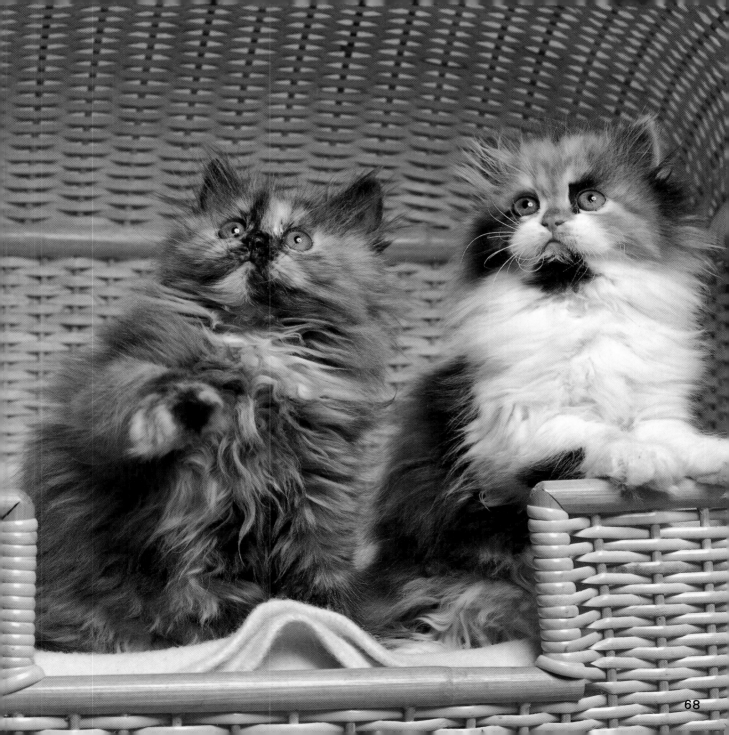

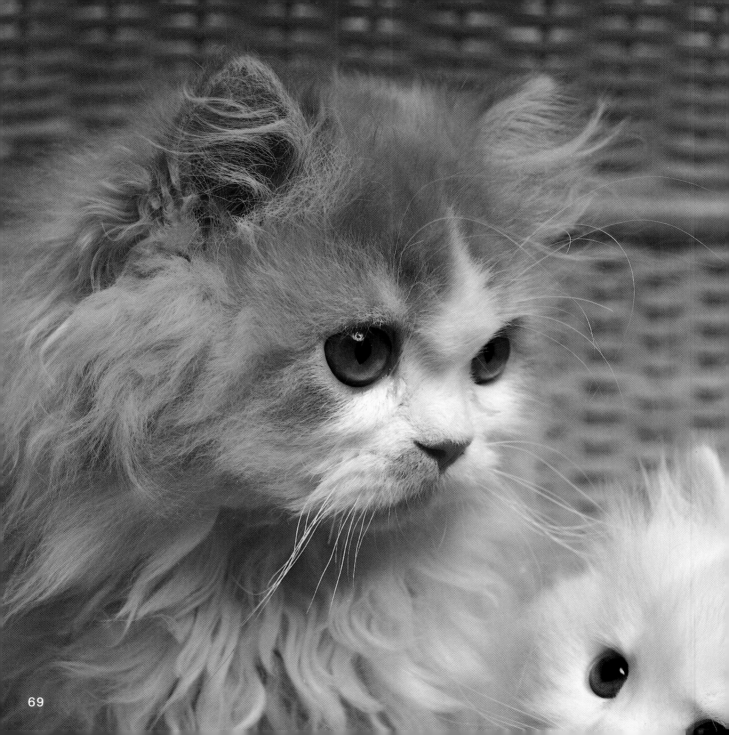

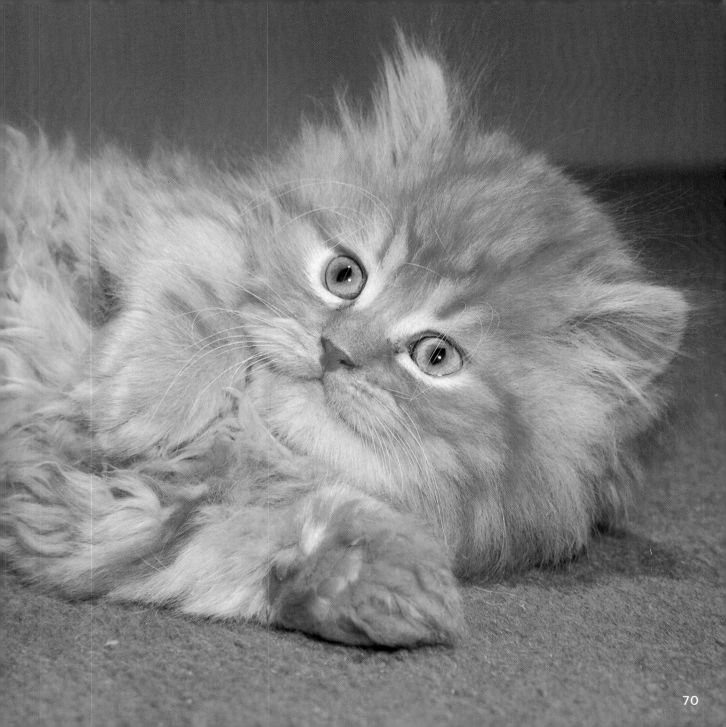

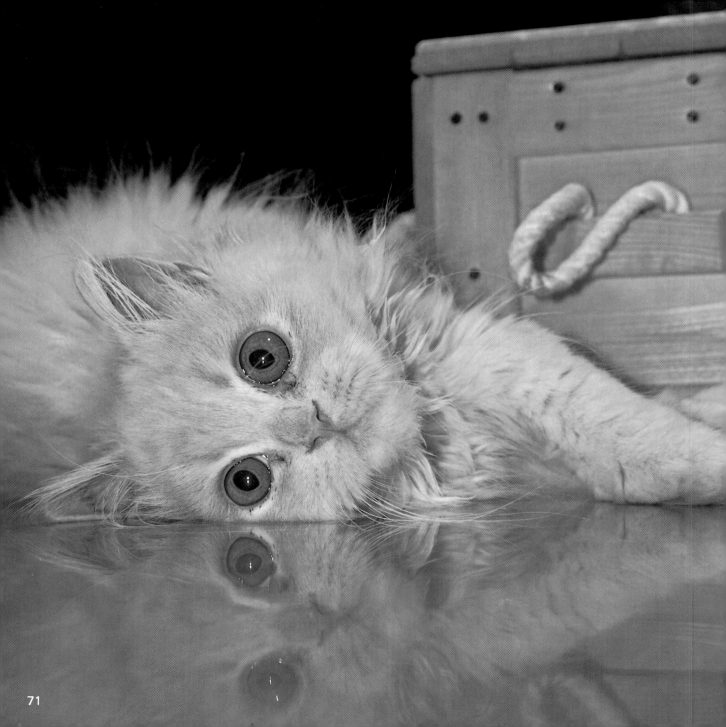

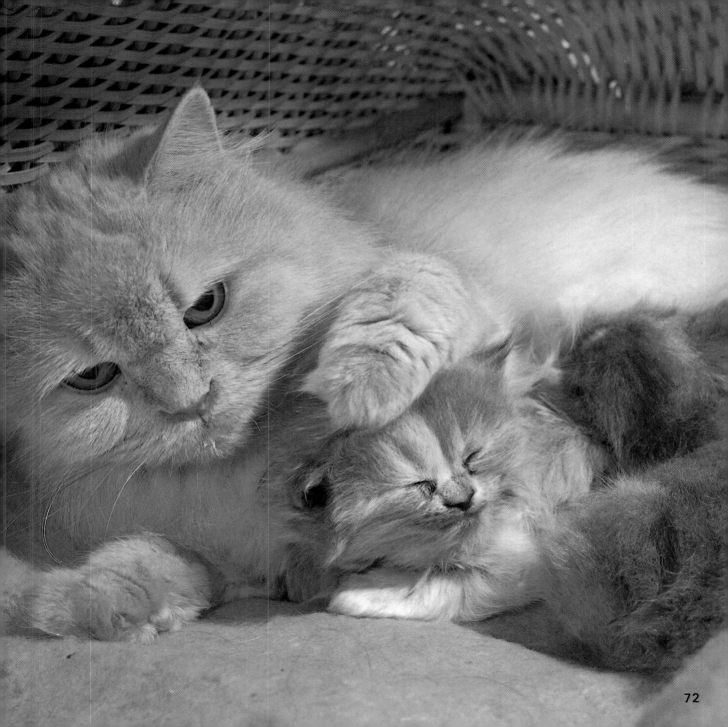

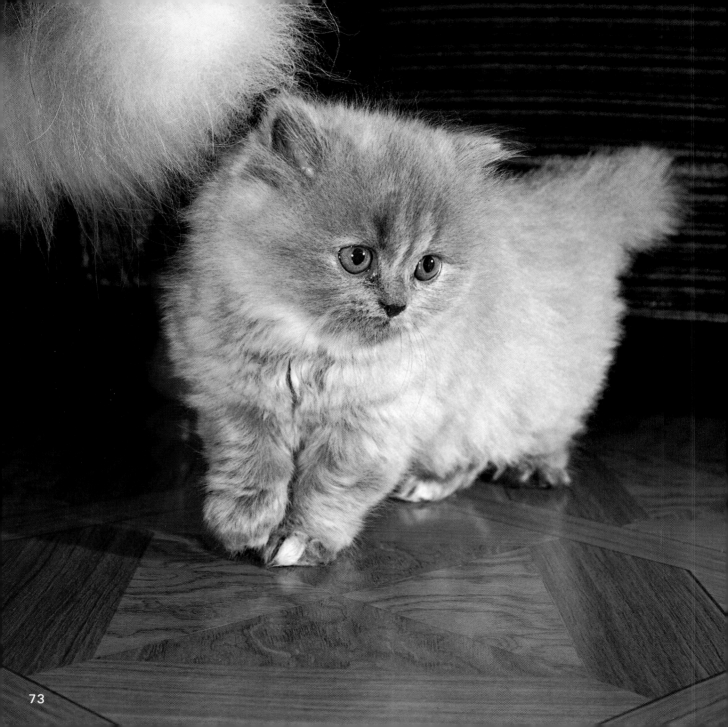

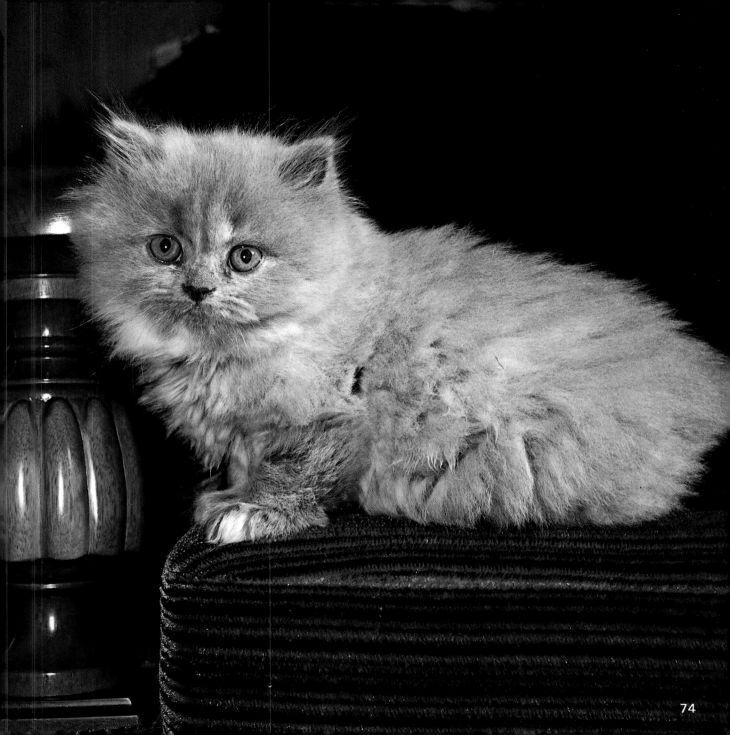

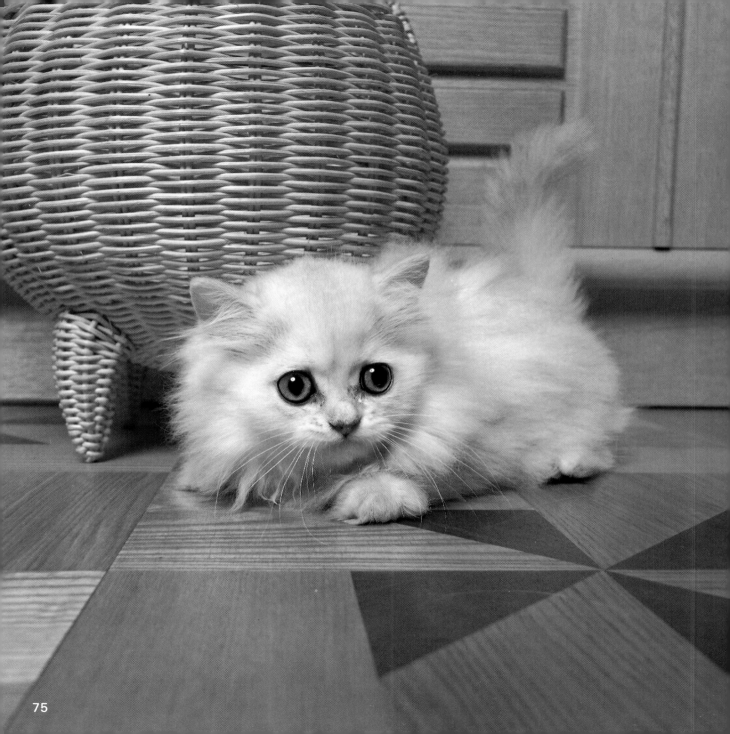

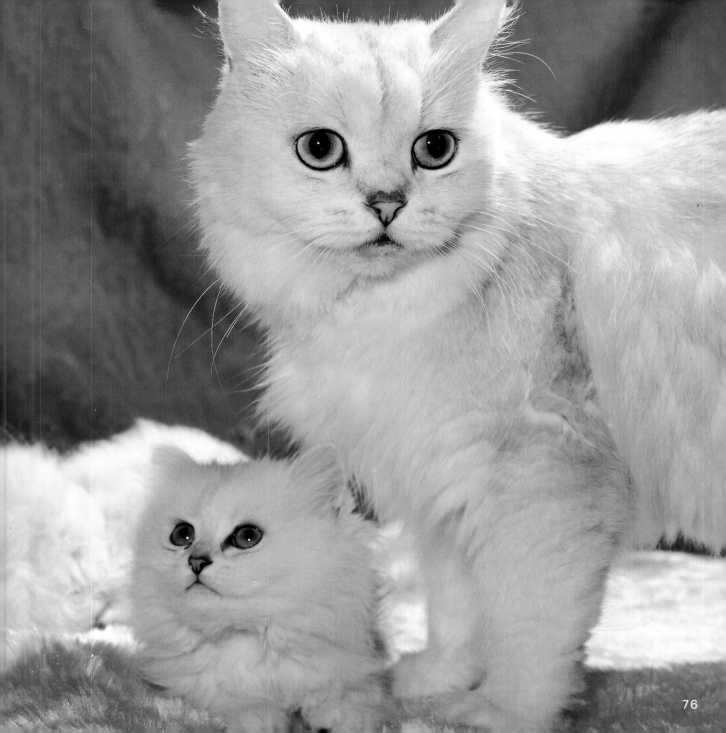

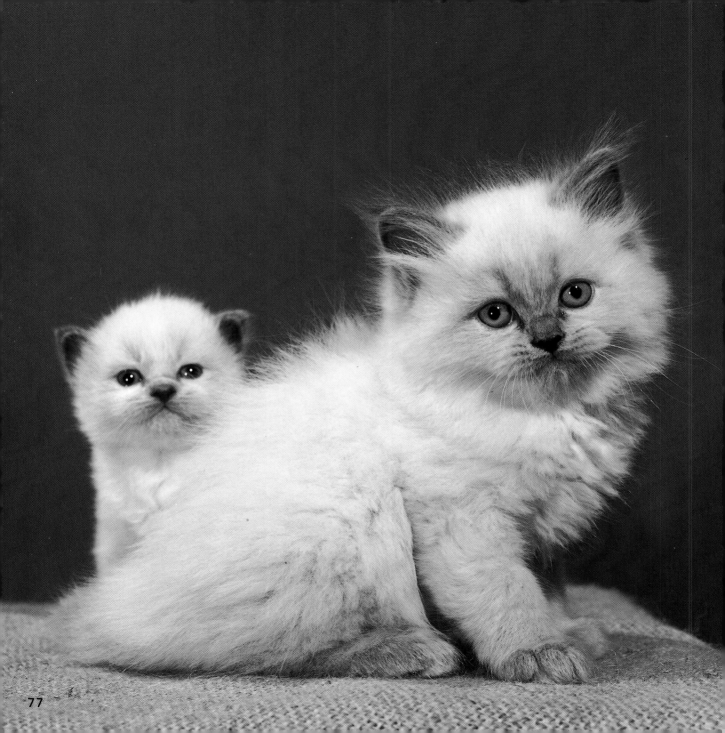

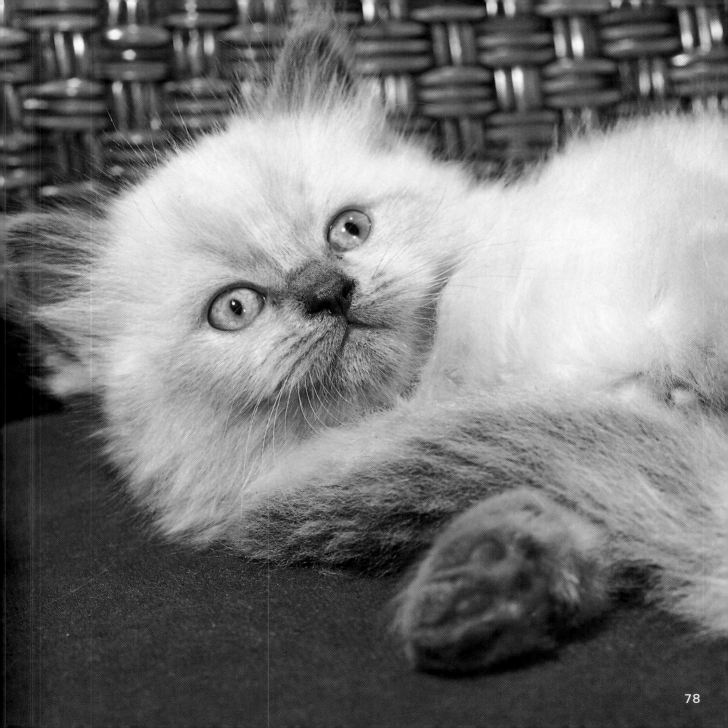

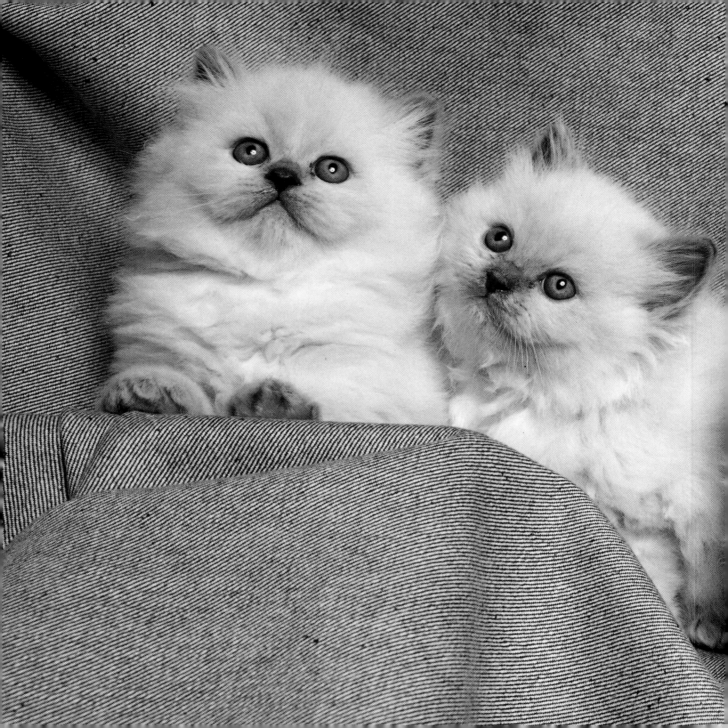

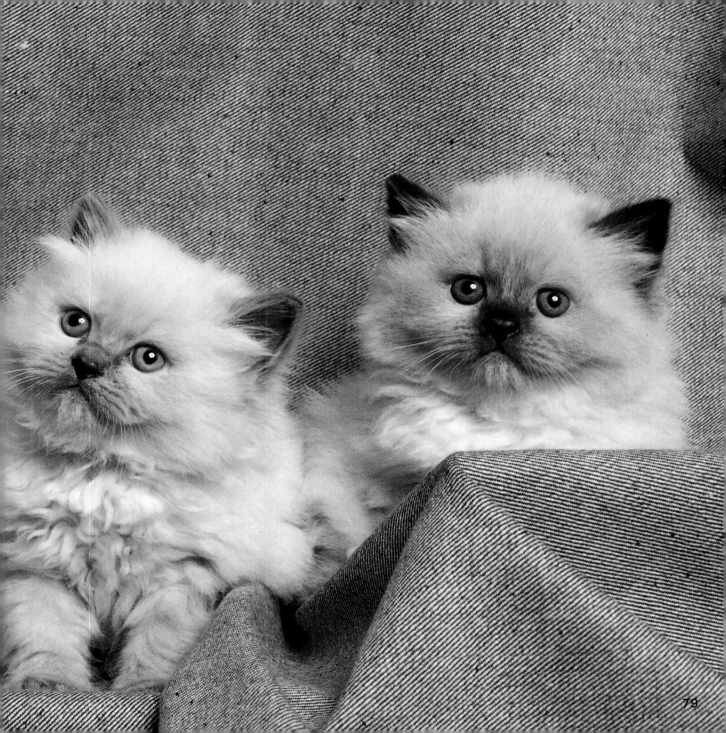

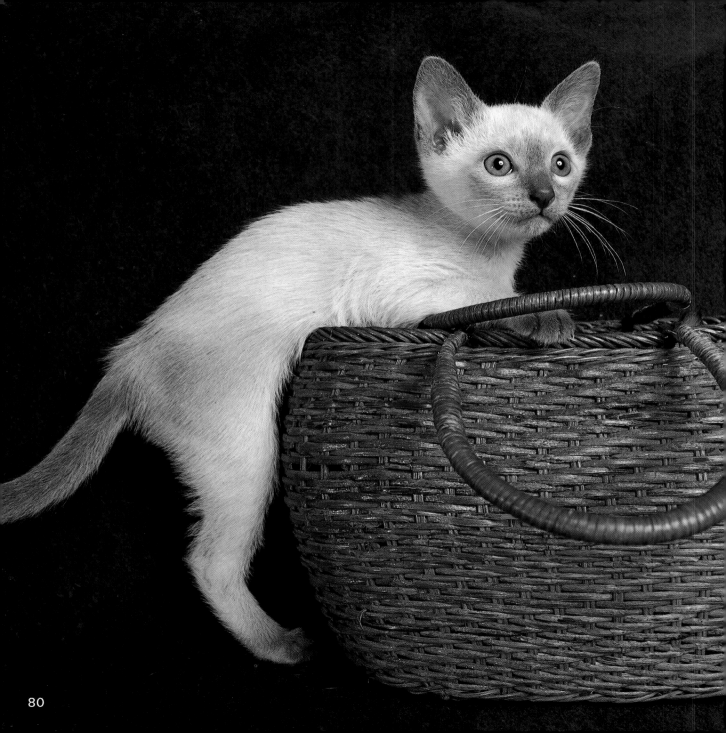

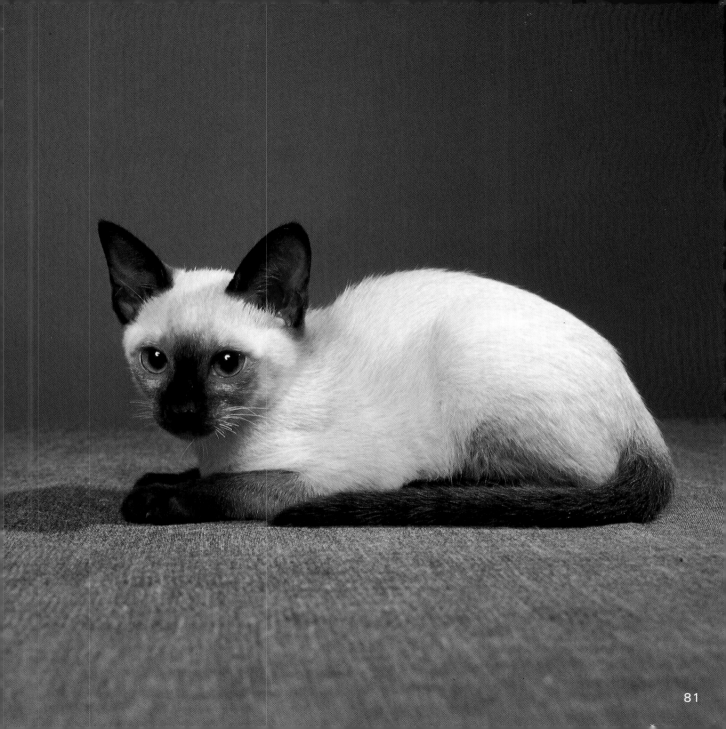

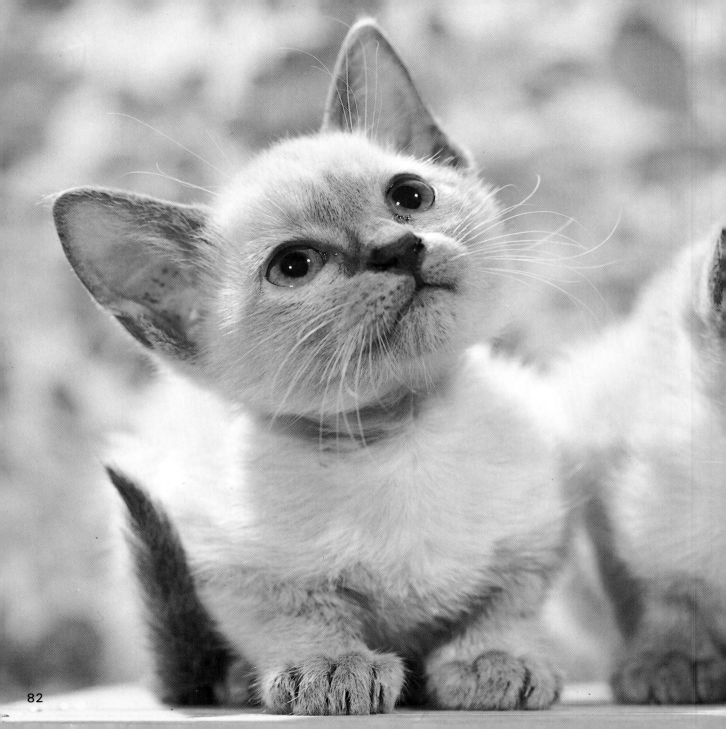

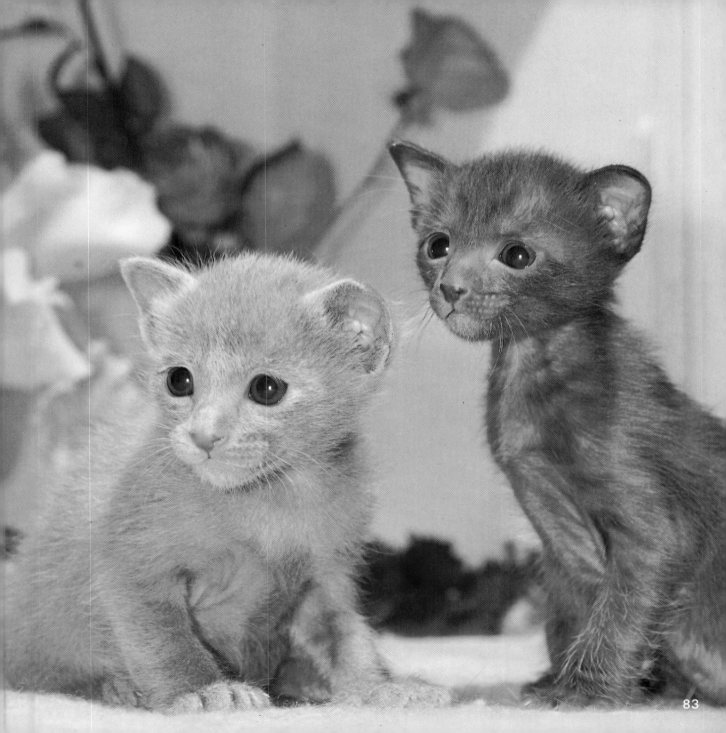

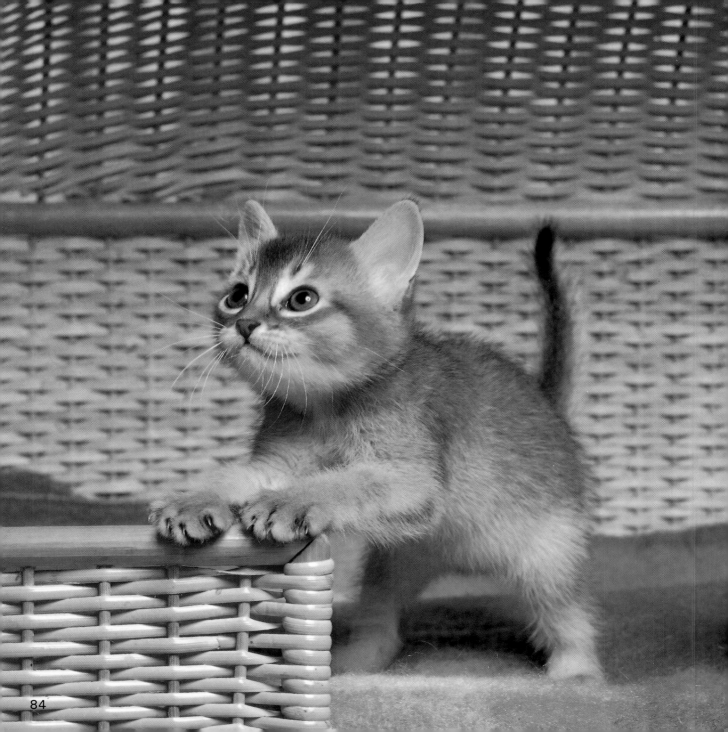

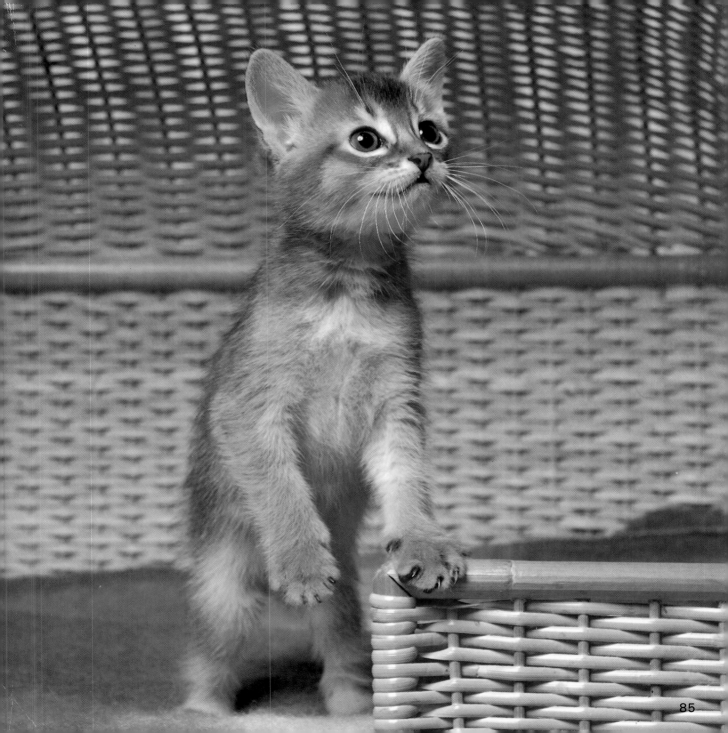

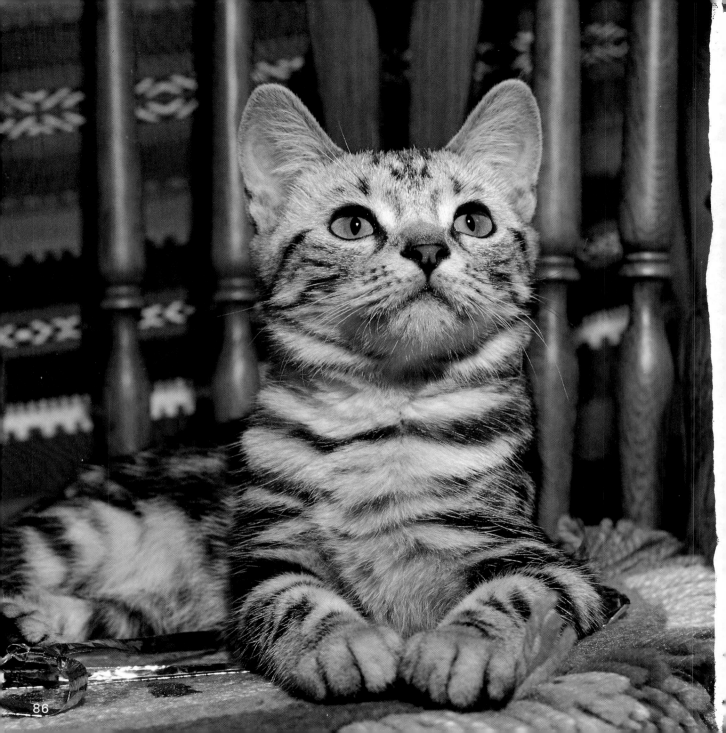